SANDRA KANTANEN LANDSCAPES

SANDRA KANTANEN LANDSCAPES

HATJE
CANTZ

CONTENTS

Foreword

by TIMOTHY PERSONS

Many have tried to foretell the future, to enable themselves to foresee their fate. Somehow reality is far more interesting—it offers us the chance to create our own challenges which, through the process of meeting them, prepare us for whatever our fates may be. Sandra Kantanen has made an art form out of these self-induced tests of endurance. From sailing across the Atlantic to exploring northern glaciers, Kantanen uses these trials of hazard to orient her focus on being a whole individual. This is the key that opens the door to understanding the continuity and depth of her work, which resides in the tenacious spirit of experimentation. Whether relying on her physical body, her mind, or materials to push the limits of her creative curiosity, Kantanen's work reflects her inquisitiveness into nature. Light and the ambiance it creates have been common denominators through her entire career. A good example of this can be found in two still lifes from 1998, *Veranda* and *Breakfast*. Here Kantanen washes her photographic images as if they were shrouded in a pale mist. These should not be confused with the white works of Paul Graham's *American Night* (2003) as Kantanen, unlike Graham, reveals her object like a painter would, unveiling the content through the mood in which it rests. It's in this milky softness of tone that Kantanen finds her poetic strength. The objects in both pictures seem suspended in time, casting no shadows.

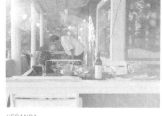

VERANDA

Sandra Kantanen has never shied away from the eastern influence she assimilated through her travels in China, Japan, and Tibet. These impressions manifested themselves in her choices of material and environments to photograph. On first glance these panoramic scenes, such as *Field* (2002), seem ideal—yet in reality they are slowly dying through misuse and pollution. Printed on aluminum plates coated with finely sanded gouache, these ink-injected images feel almost alive with their textured surfaces and dark hues. They absorb the light rather then reflect it. Unlaminated, in their raw essence they appear to be the paintings Kantanen always longed to make; they redefine how photography can be seen and presented, however impractical they are to produce.

The *Reflected Lake* series, which began in 2008, was a new departure for Kantanen. Here she shares a common language of perspective with the landscapes of

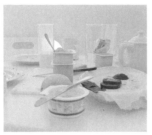

BREAKFAST

Bill Jacobsen and Gerhard Richter. Kantanen combines the blurred effect of Jacobsen with the color strokes of Richter by compiling and stretching the pixels of several negatives into one final image. Her photographs feel more like a collage in which each layer reveals a secret from the one before it. They open questions concerning how we move within nature and the consequences that result from that interaction. Sometimes beautiful and at other times eerily serene, these compositions aren't what they seem to be. Together they form a narrative all their own.

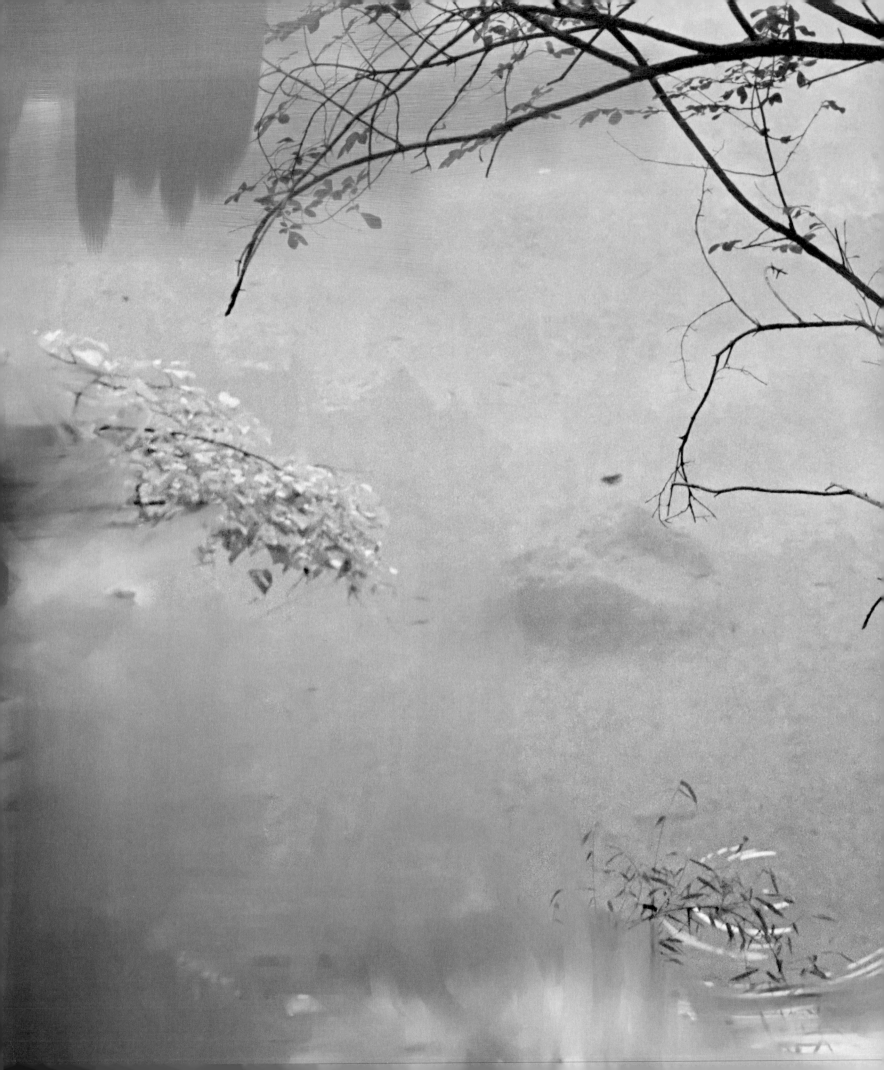

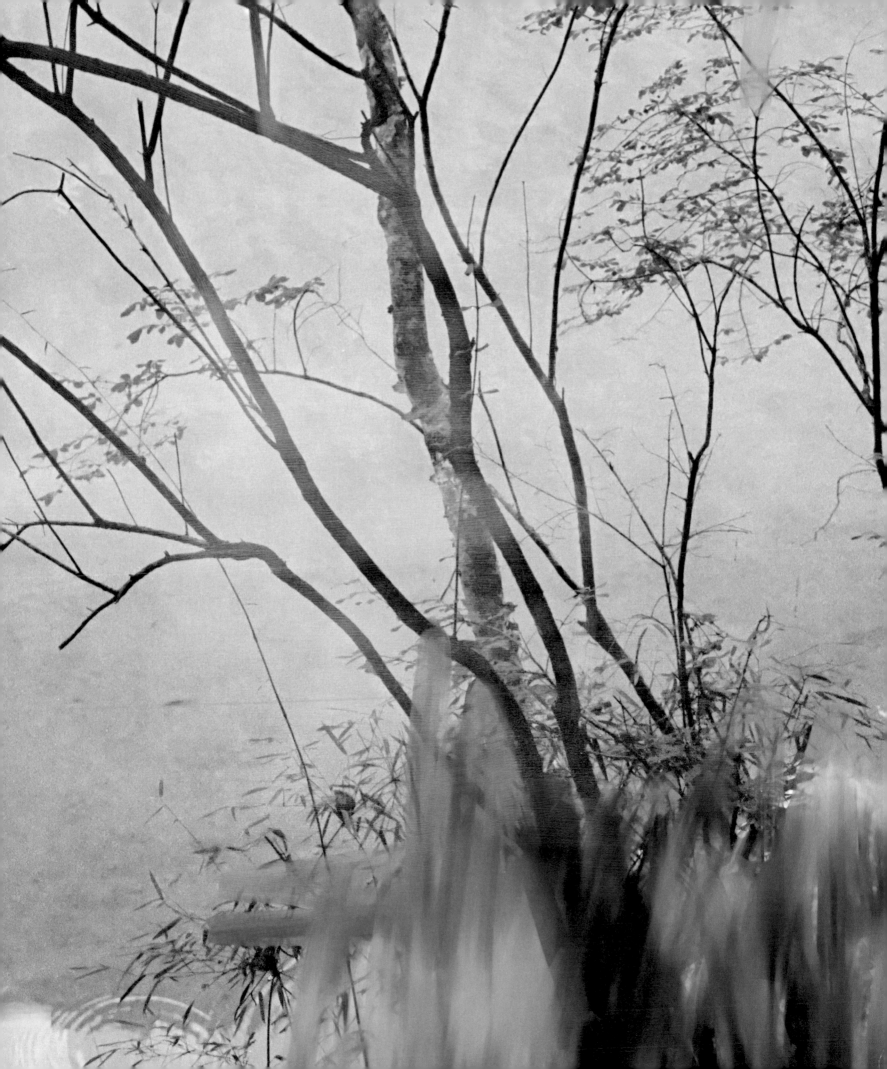

Untitled (Lake 3), 2009
Pigment print on paper
82 x 70 cm

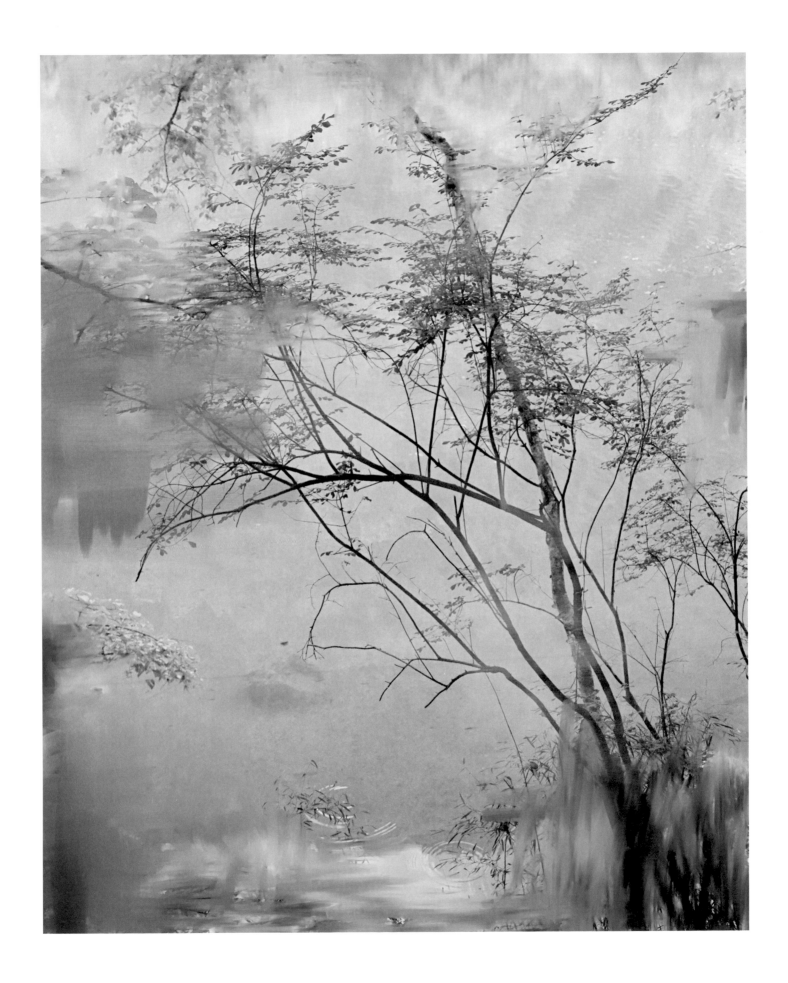

Untitled (Lake 1), 2009
Pigment print on paper
128 x 108 cm

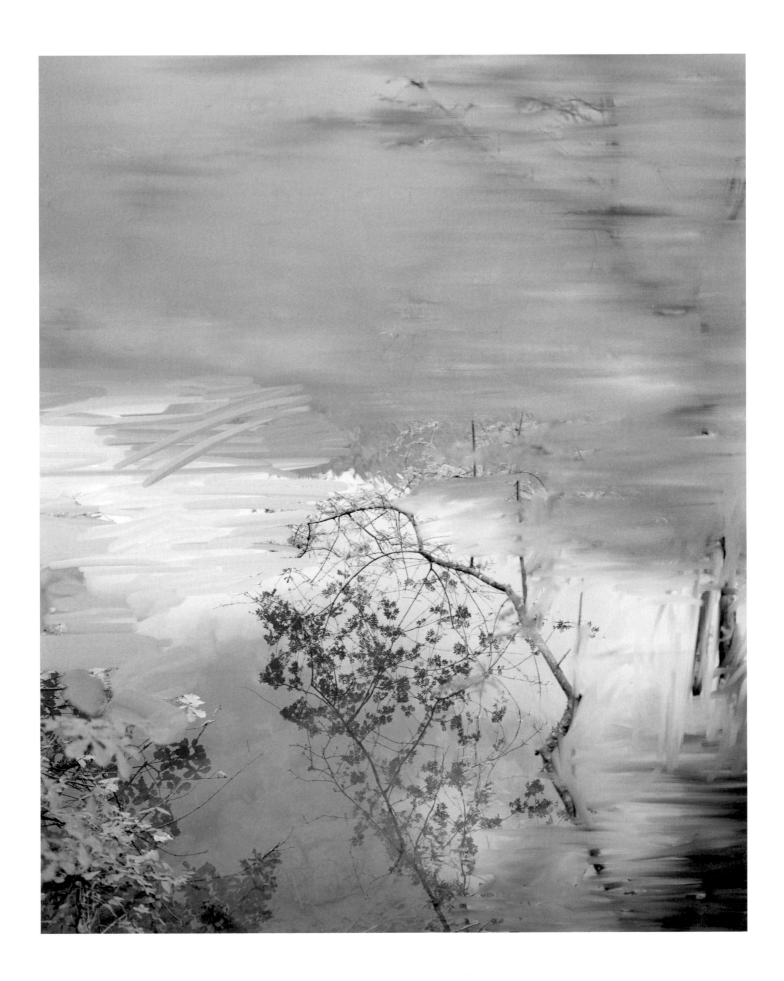

Untitled (Lake 2, Fishpond), 2009
Pigment print on paper
128 x 108 cm

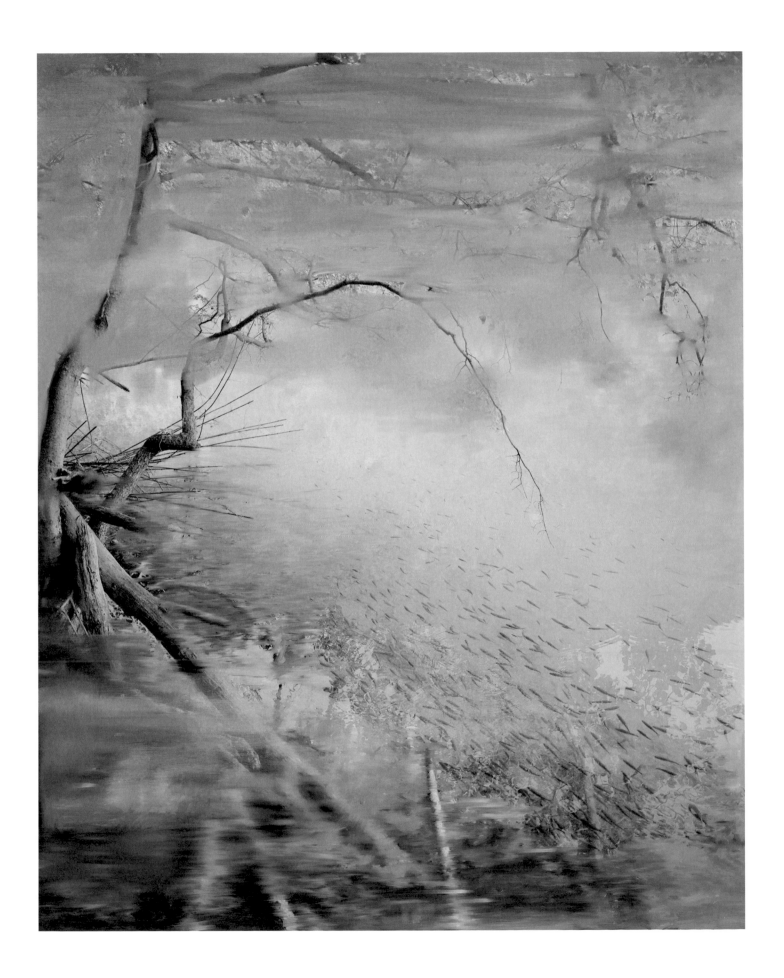

Untitled (Lake 4), 2010
Pigment print on paper
62 x 50 cm

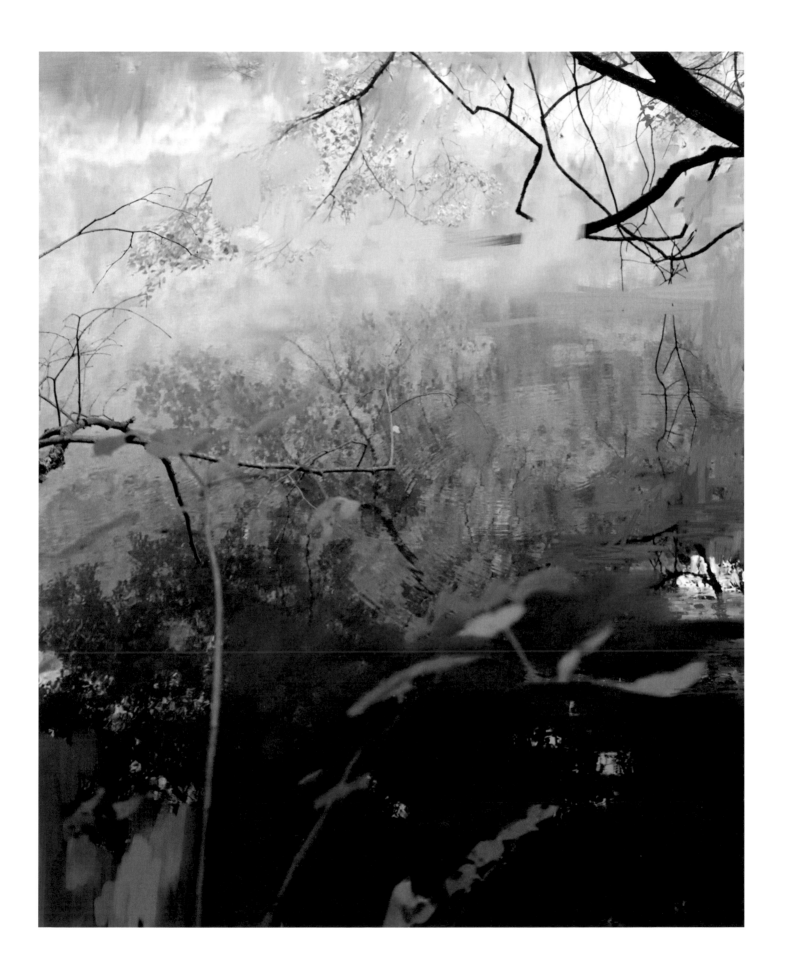

Untitled (Lake 6, Fishpond), 2010
Pigment print on paper
128 x 108 cm

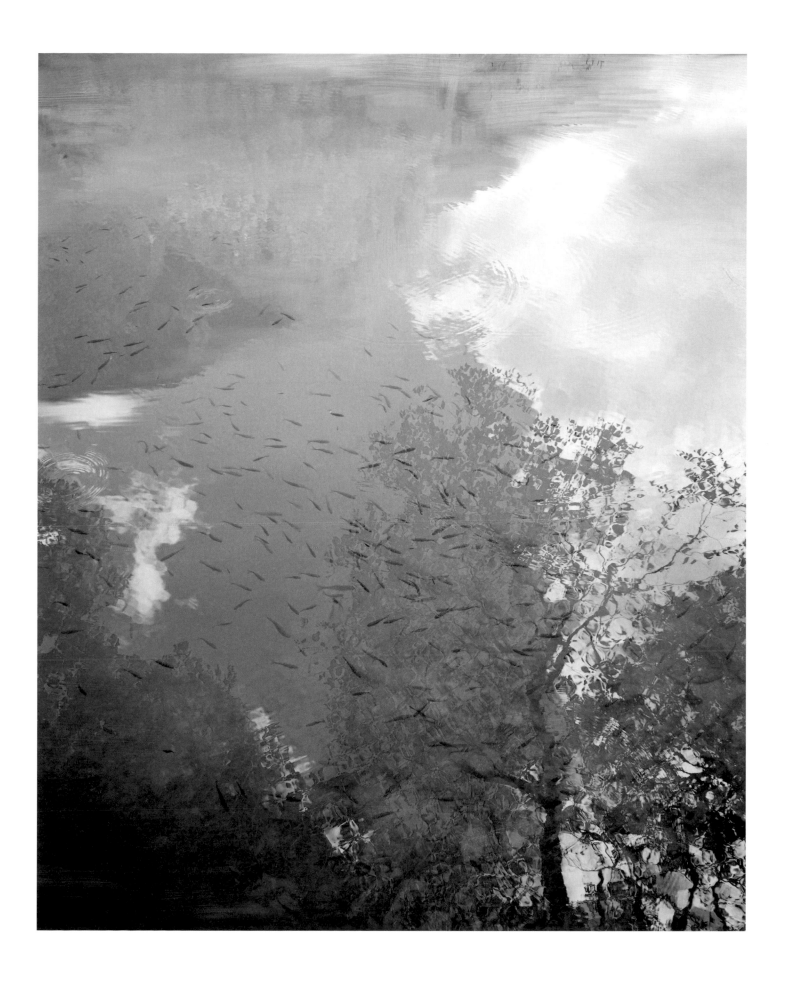

Untitled (Lake 7), 2010
Pigment print on paper
82 x 70 cm

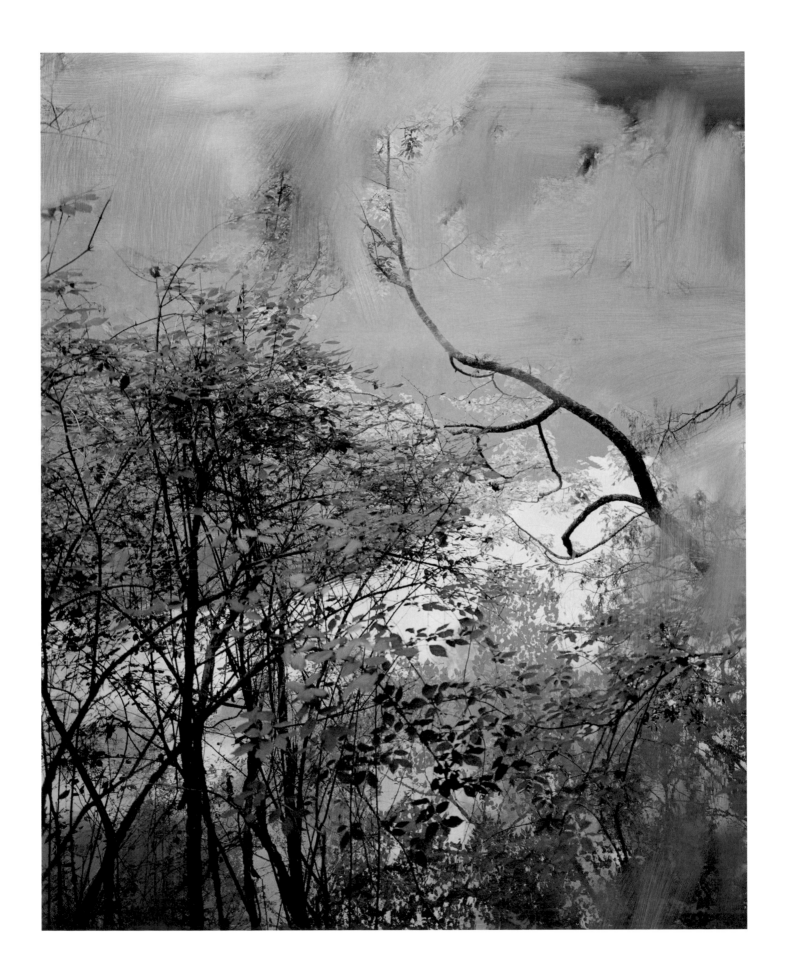

Untitled (Lake 5), 2010
Pigment print on paper
82 x 70 cm

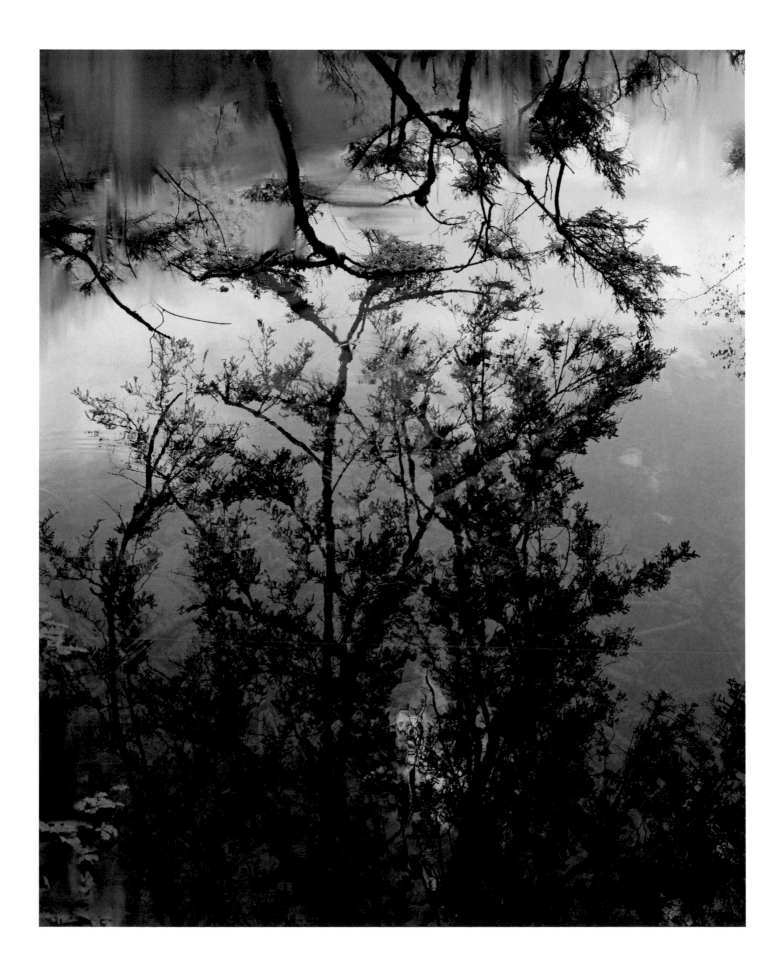

Untitled (Woods 1), 2010
Pigment print on paper
108 x 128 cm

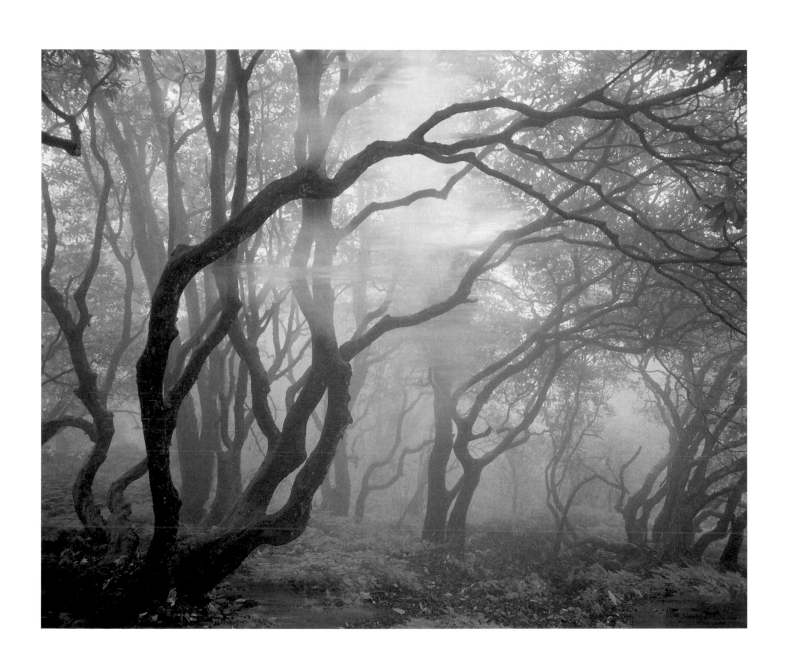

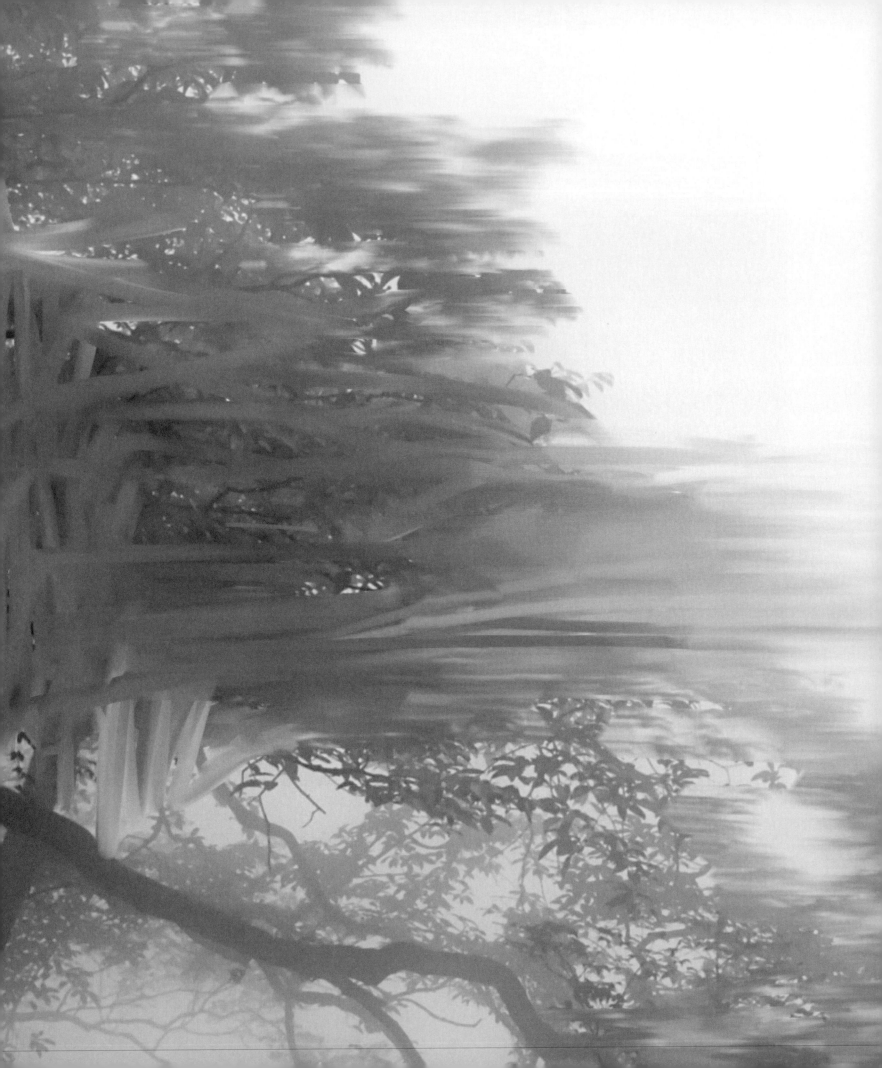

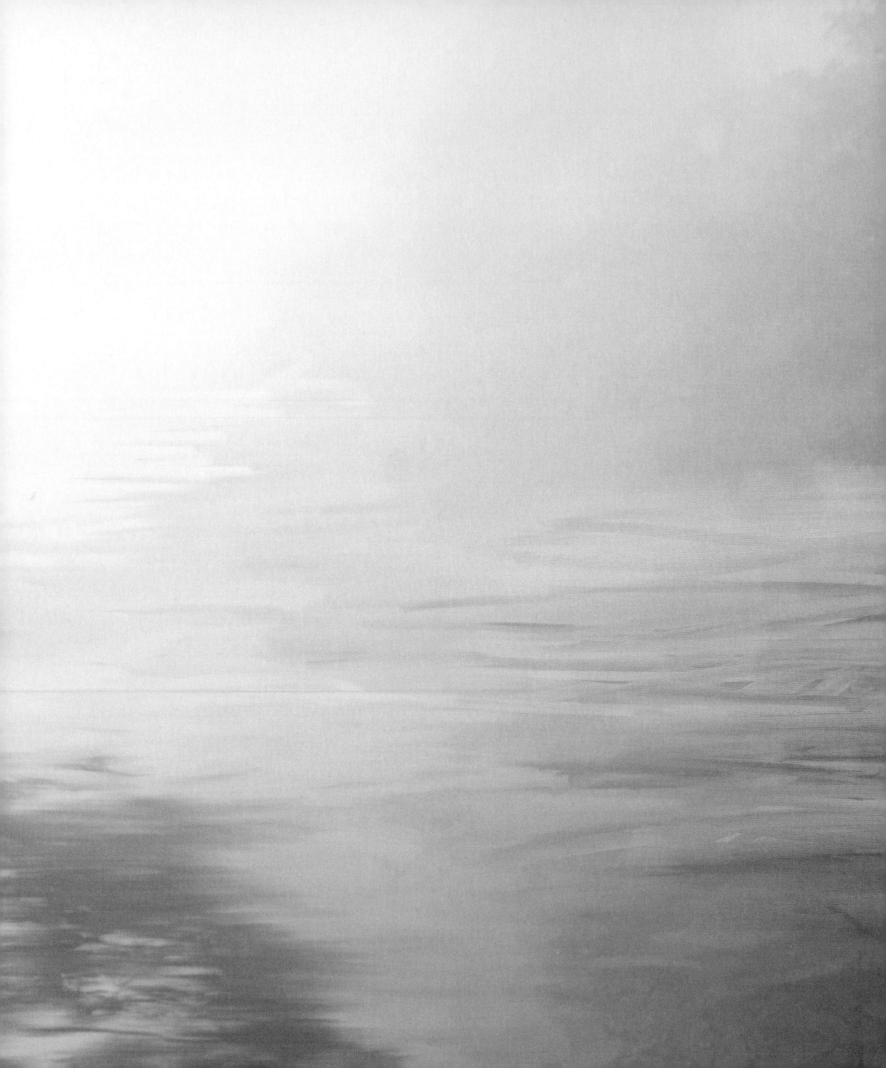

Untitled (Mountain 4), 2009
Pigment print on paper
82 x 70 cm

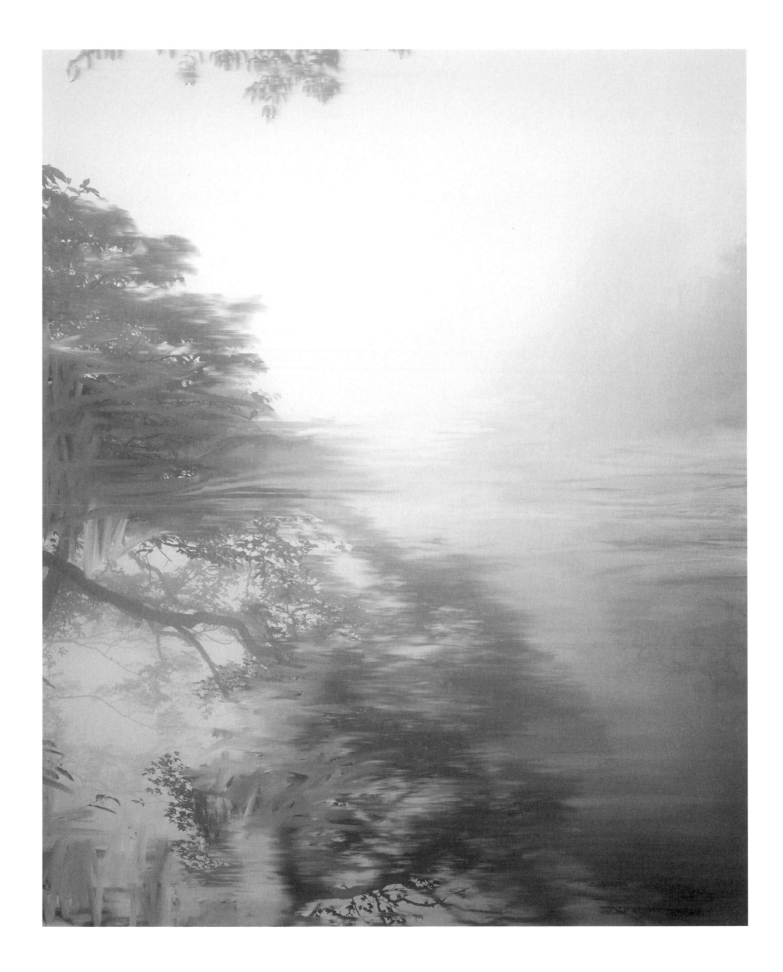

Untitled (Mountain 1), 2009
Pigment print on paper
128 x 108 cm

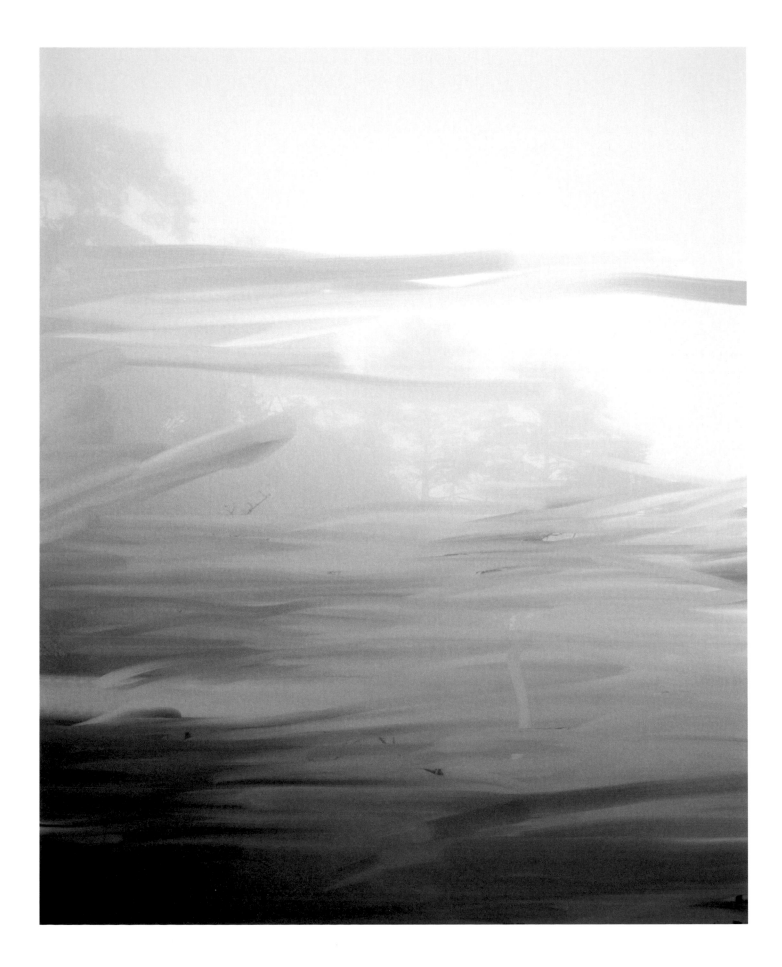

Untitled (Mountain 2), 2009
Pigment print on paper
128 x 108 cm

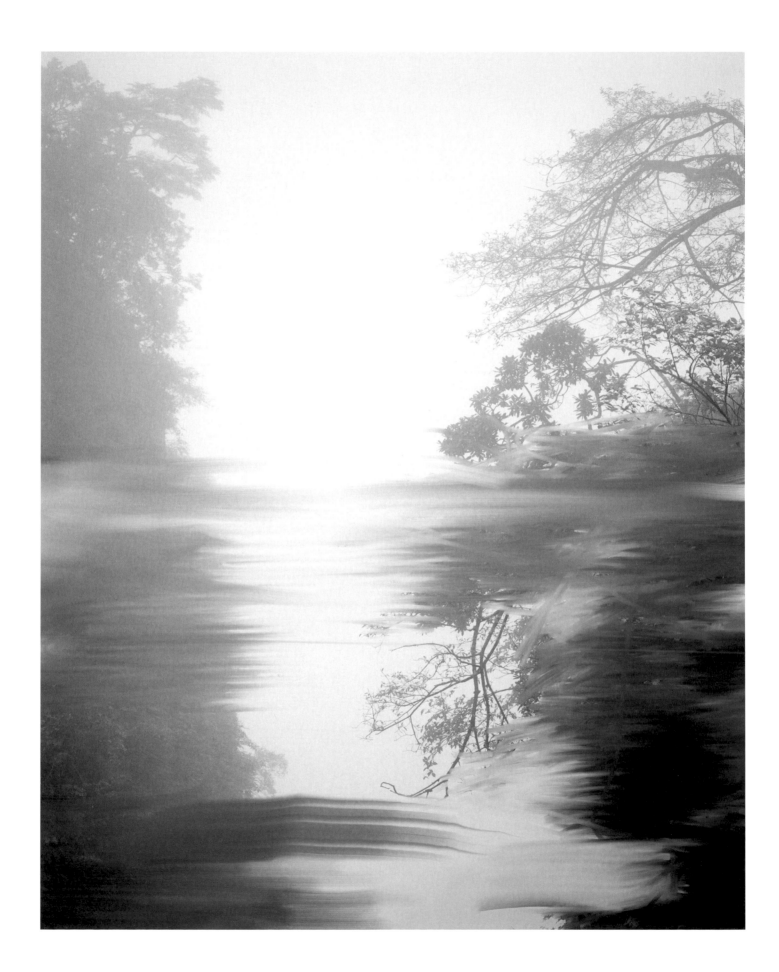

Untitled (Mountain 3), 2009
Pigment print on paper
128 x 108 cm

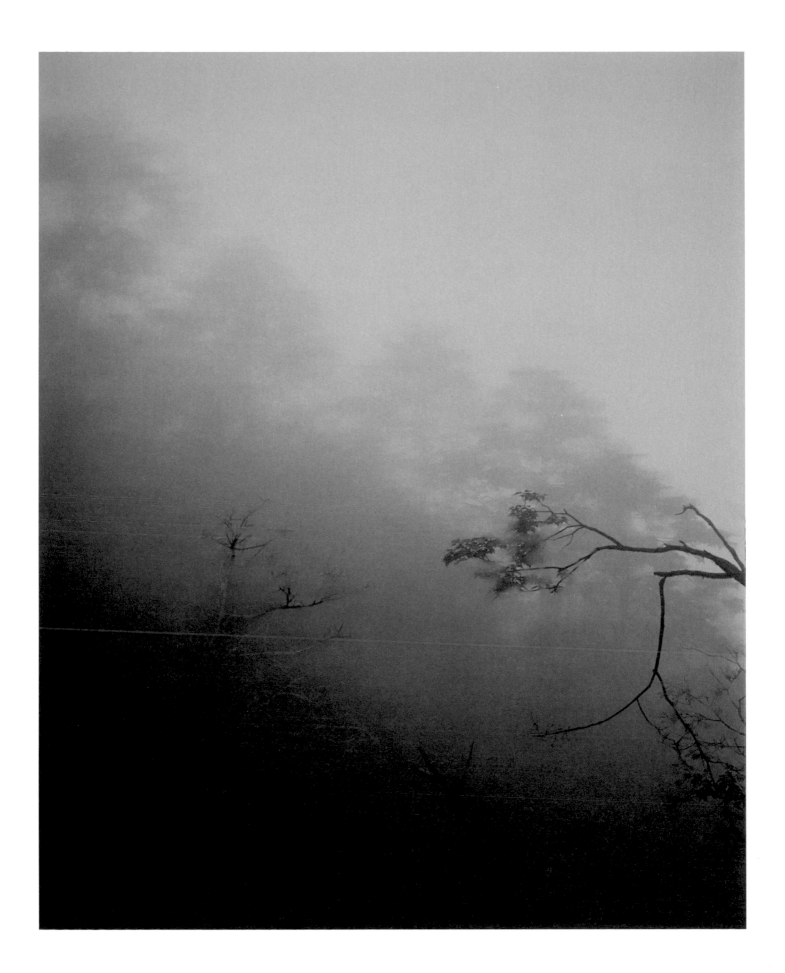

Untitled (Mountain 5), 2010
Pigment print on paper
62 x 50 cm

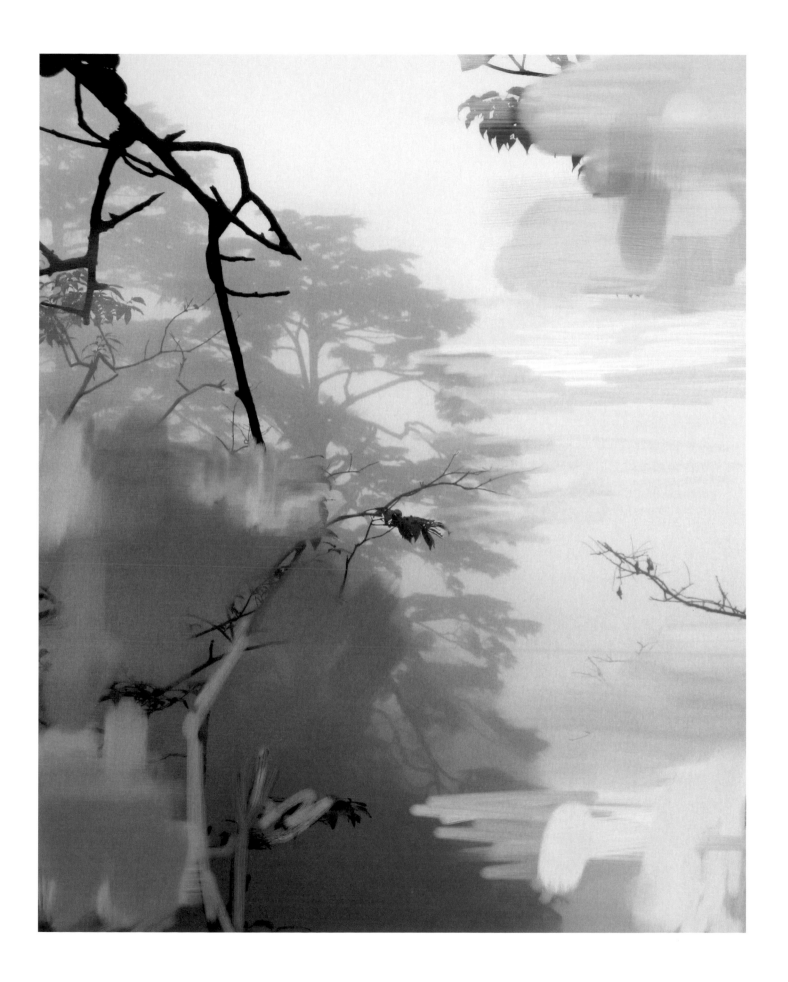

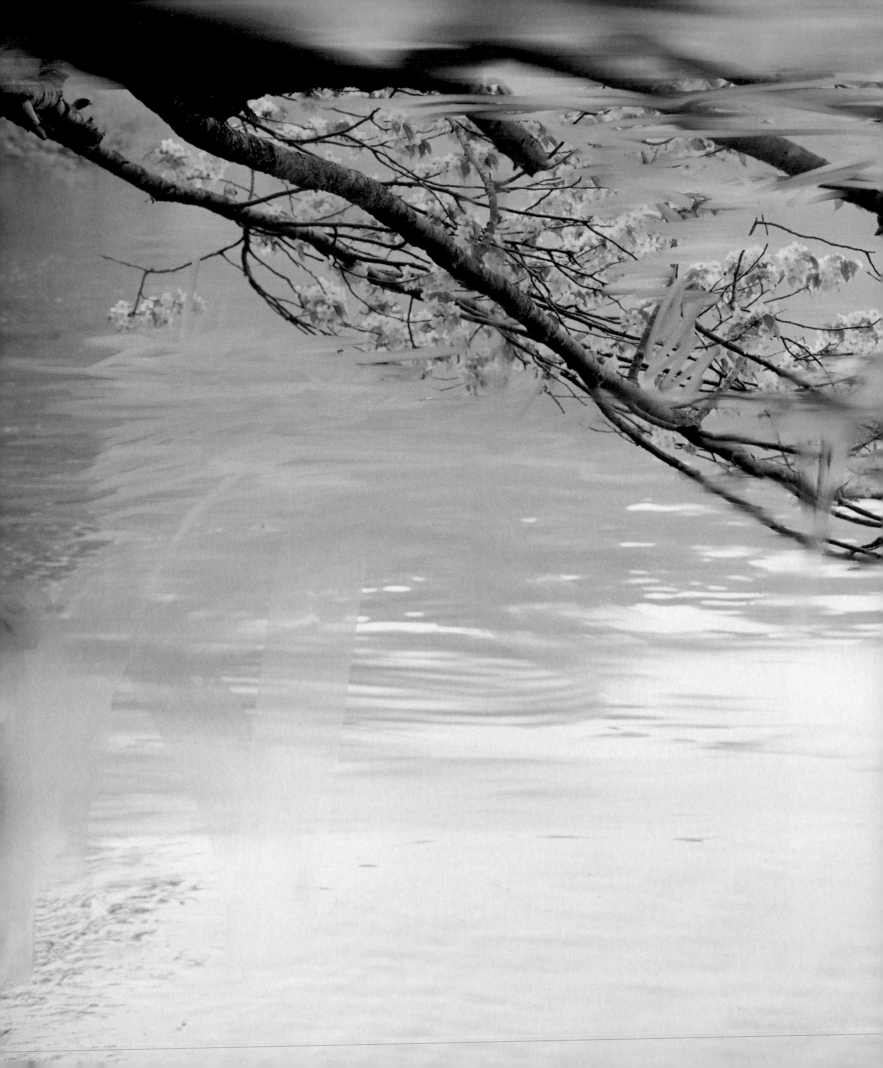

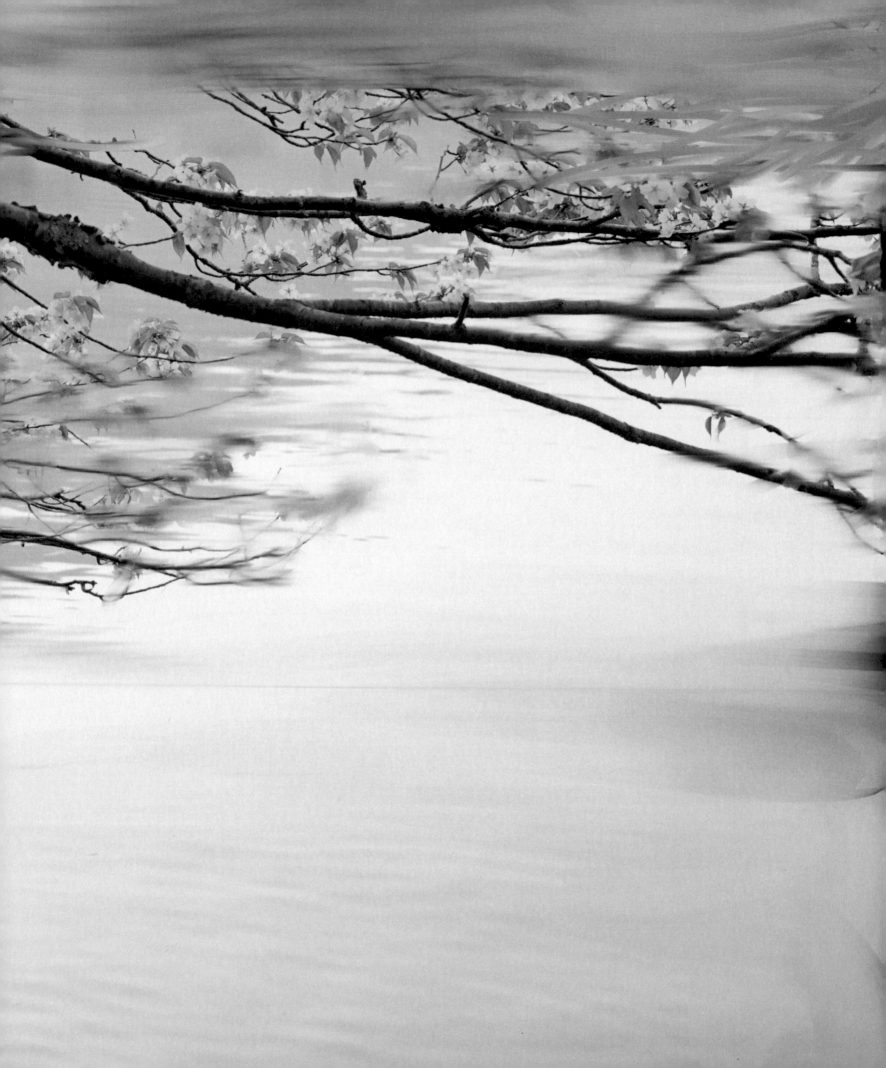

Untitled (Sakura 2), 2009
Pigment print on paper
128 x 108 cm

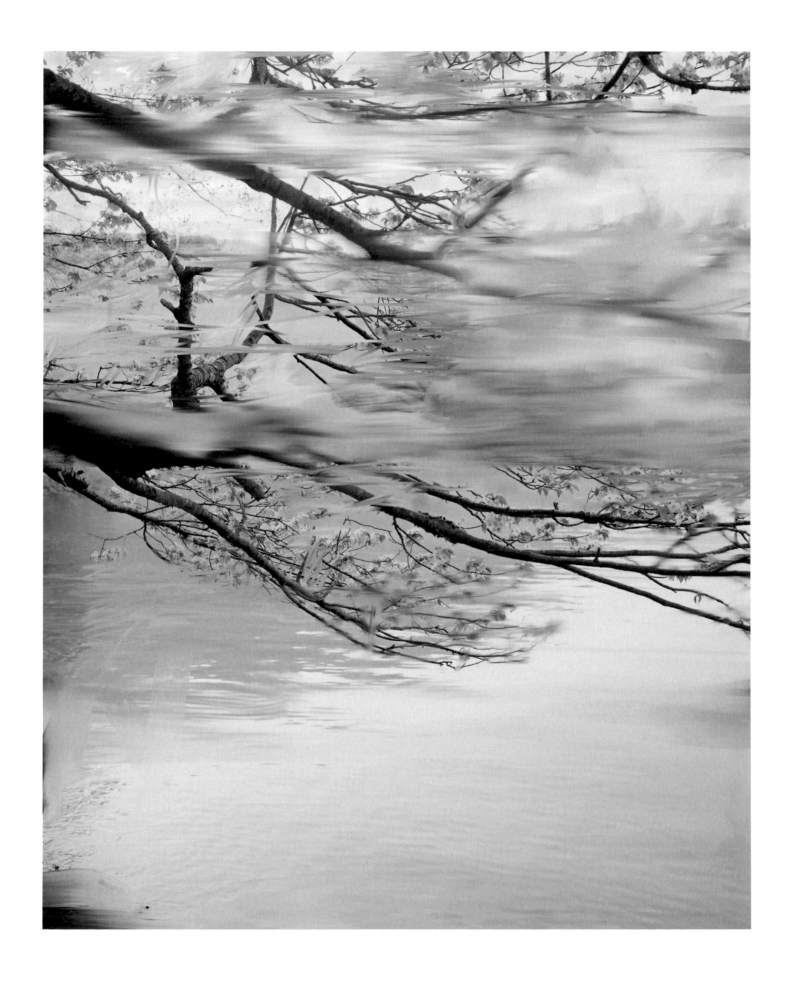

Untitled (Sakura 3), 2010
Pigment print on paper
128 x 108 cm

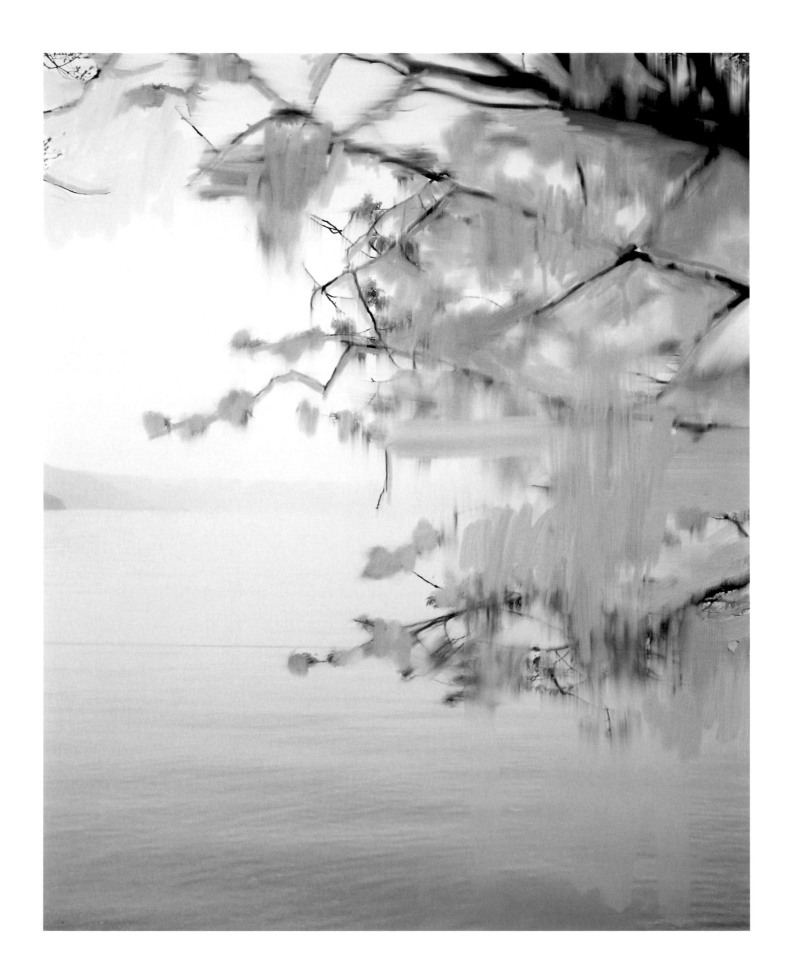

Untitled (Sakura 1), 2009
Pigment print on paper
108 x 128 cm

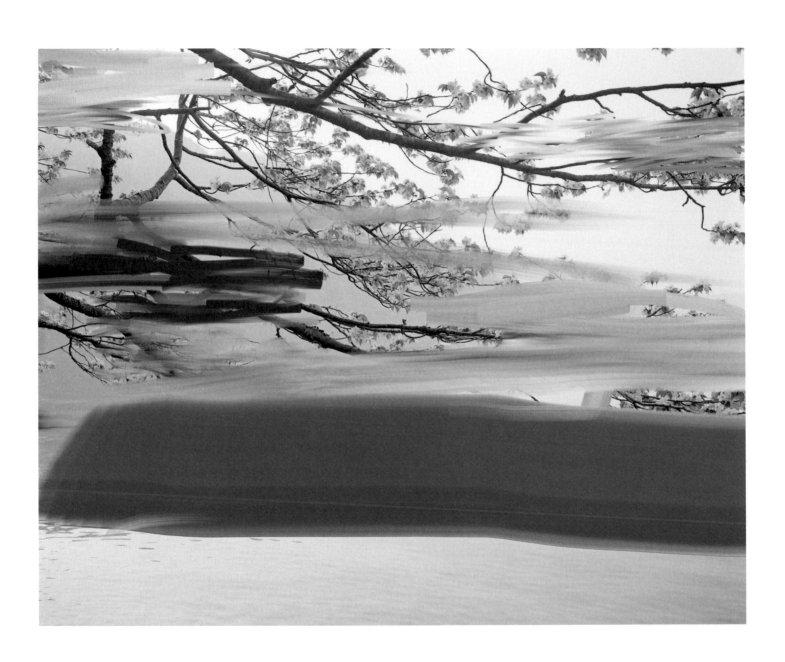

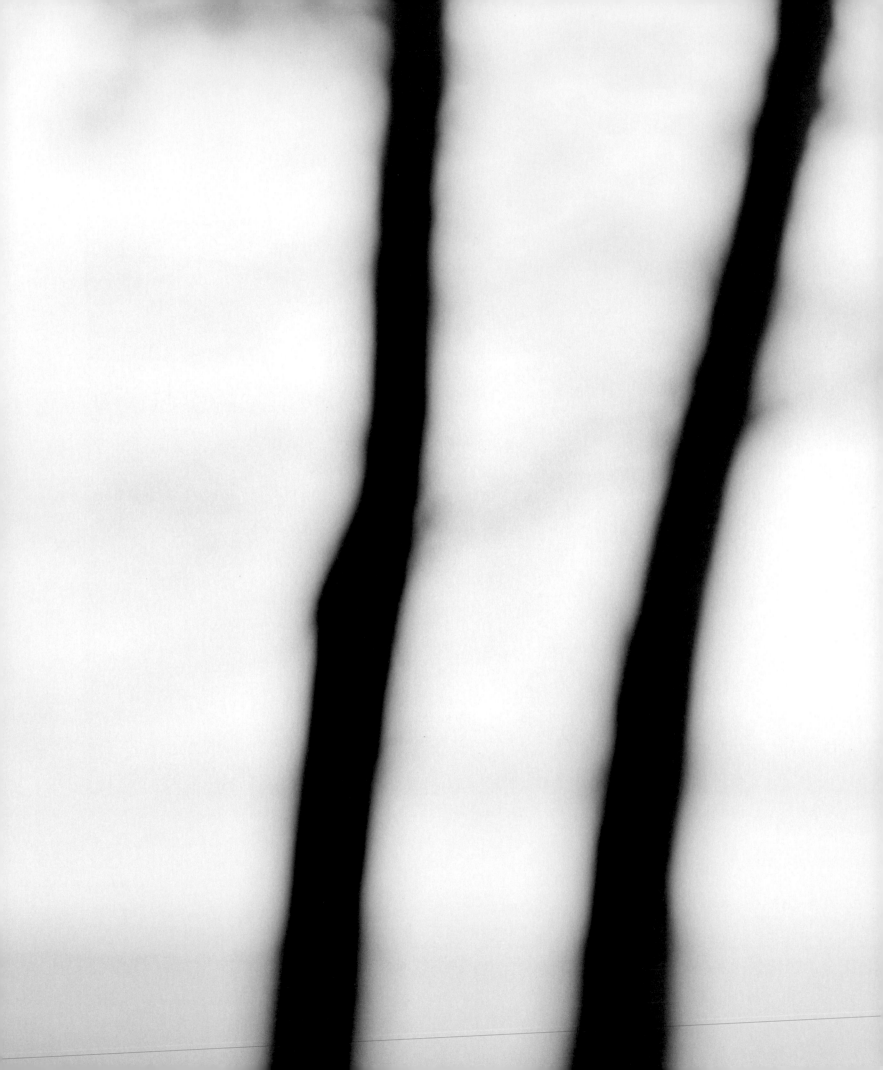

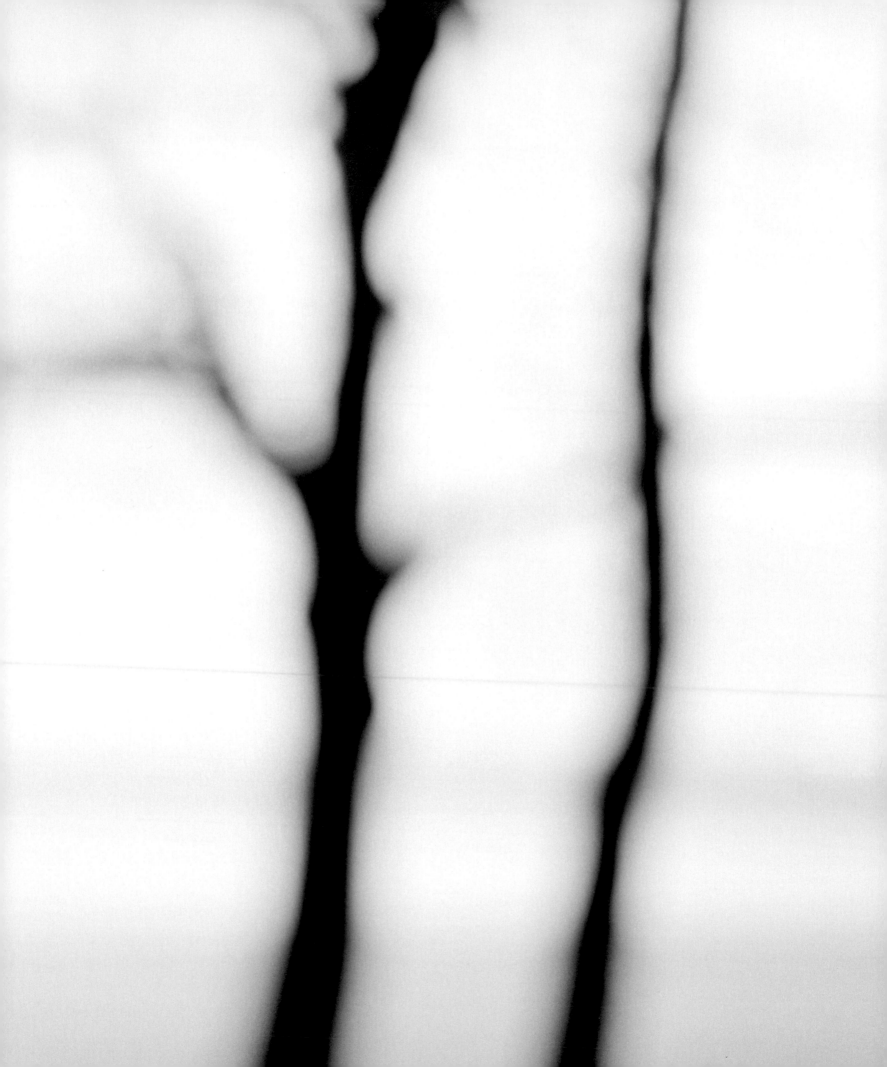

Beach 1, 2007
Pigment print on paper
122 x 142 cm

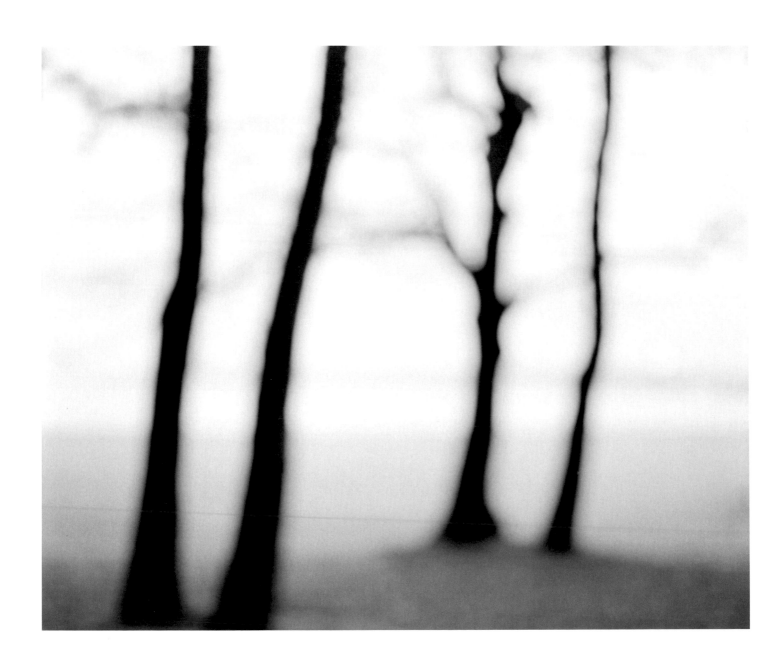

Beach 2, 2007
Pigment print on paper
142 x 122 cm

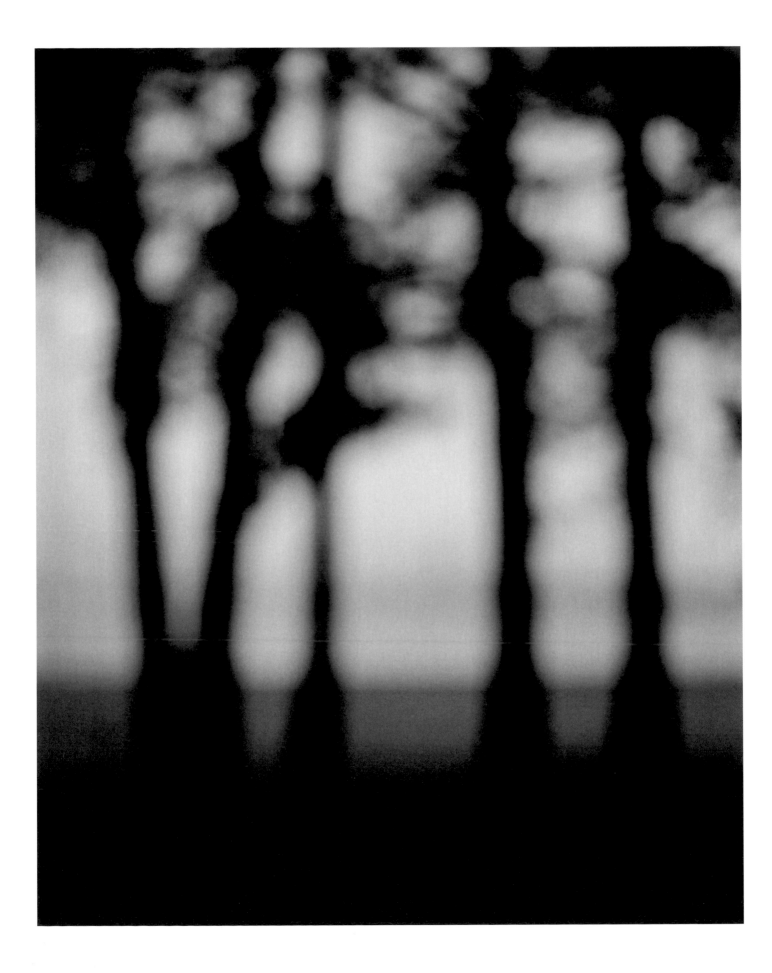

Beach 3, 2007
Pigment print on paper
142 x 122 cm

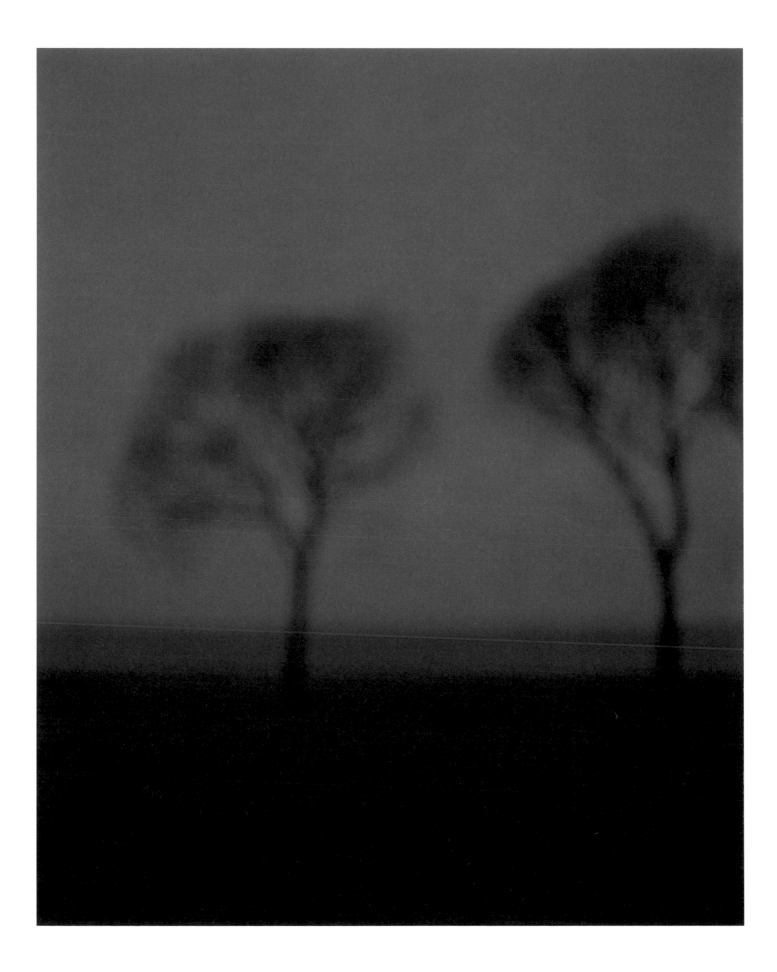

Beach 4, 2007
Pigment print on paper
142 x 122 cm

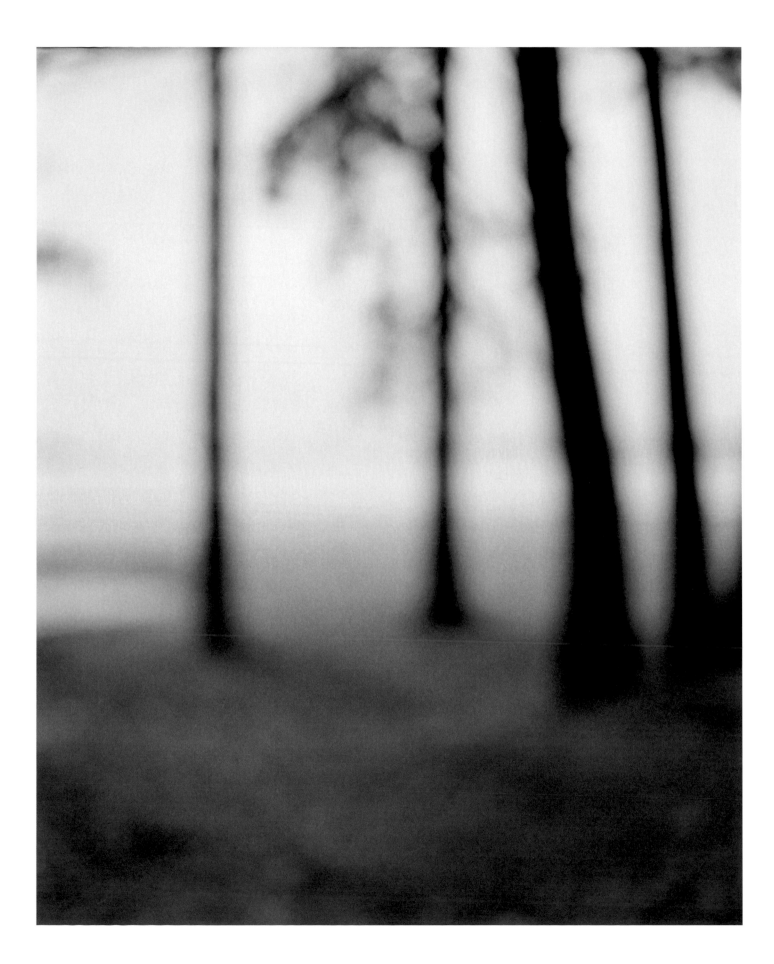

Reflection 1, 2007
Pigment print on paper
142 × 122 cm

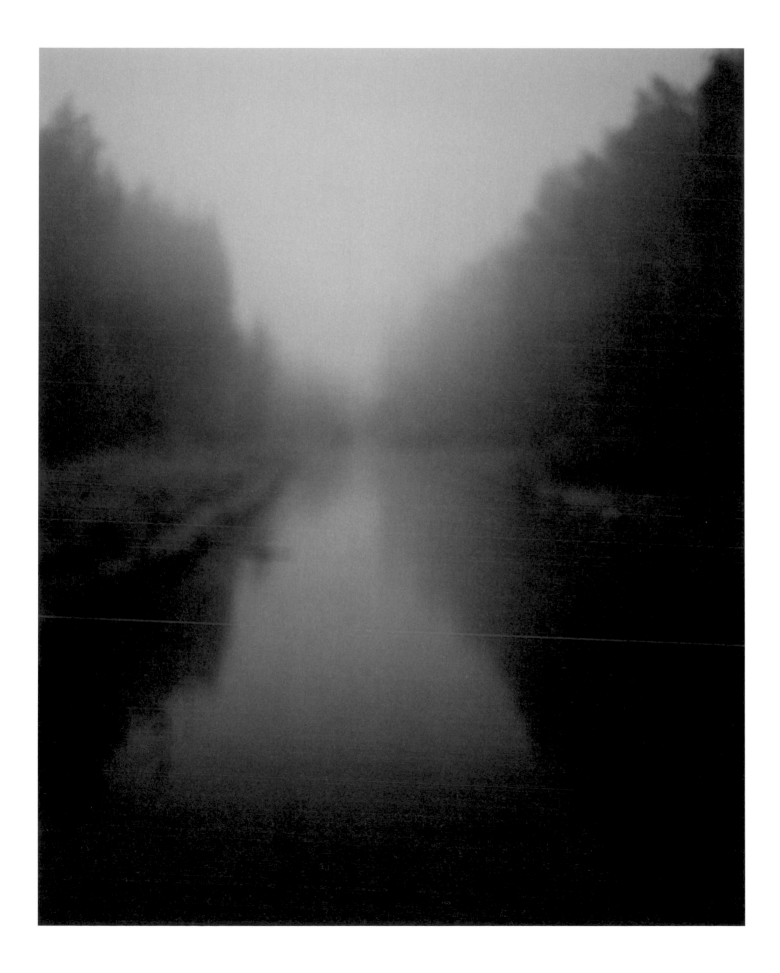

Untitled (Belomar Canal at Night), 2010
Pigment print on paper
82 x 70 cm

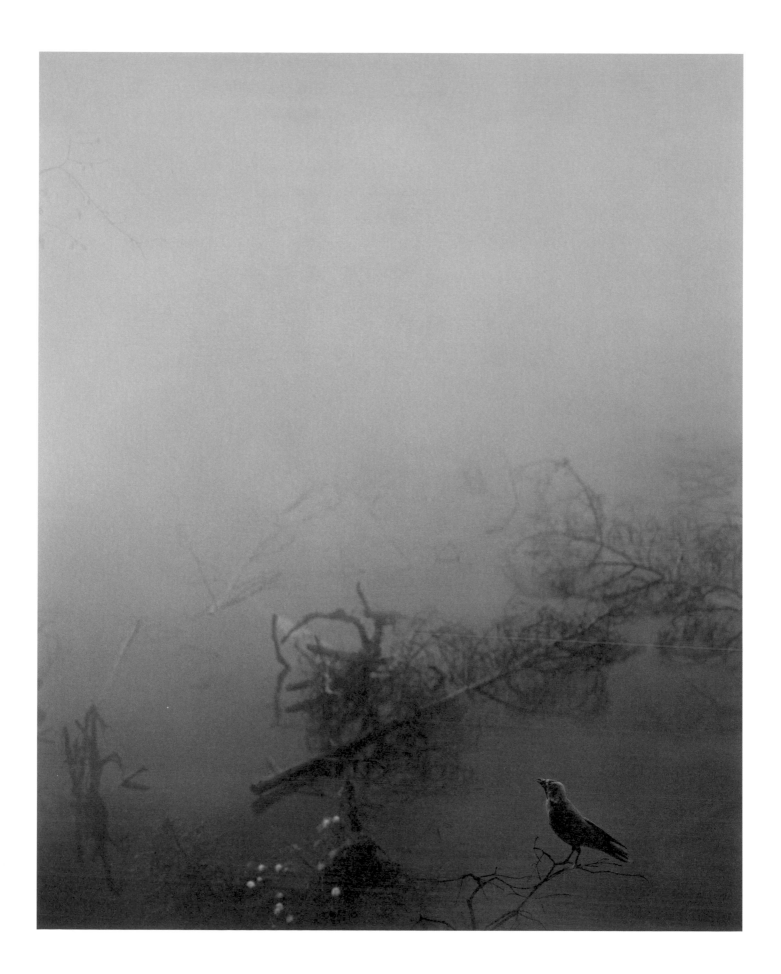

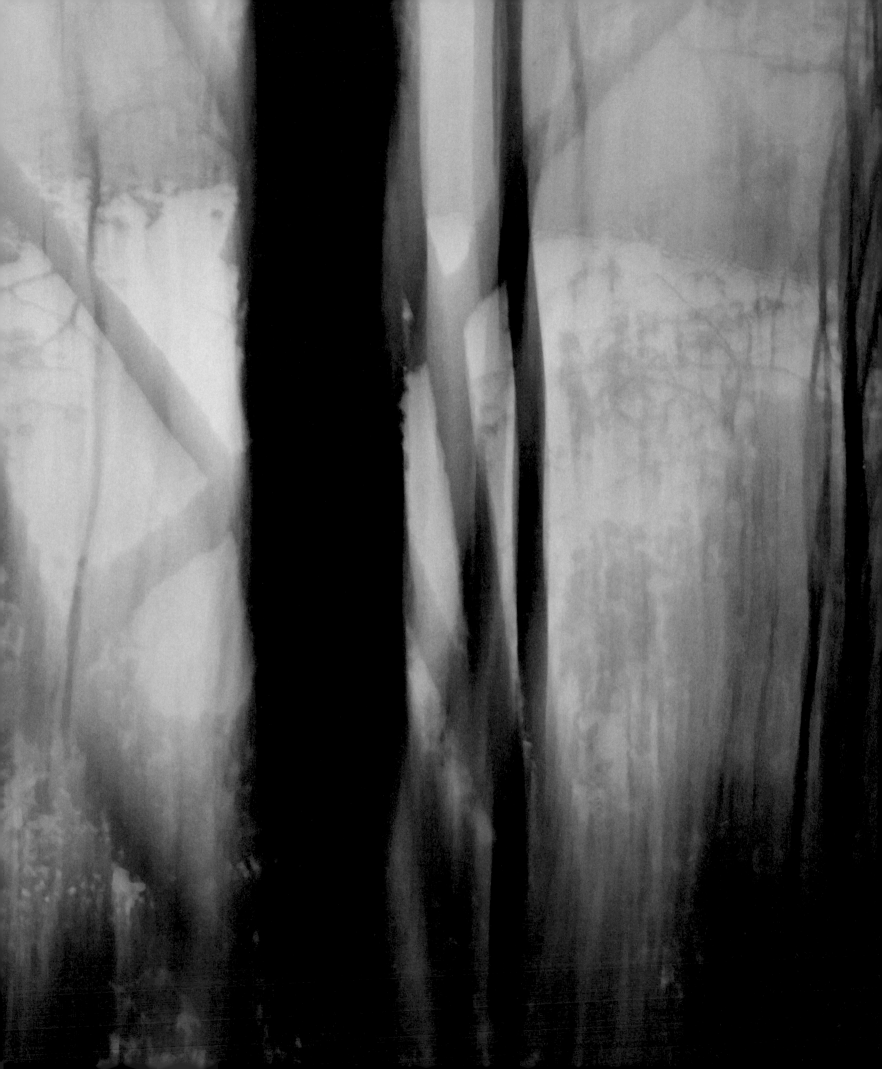

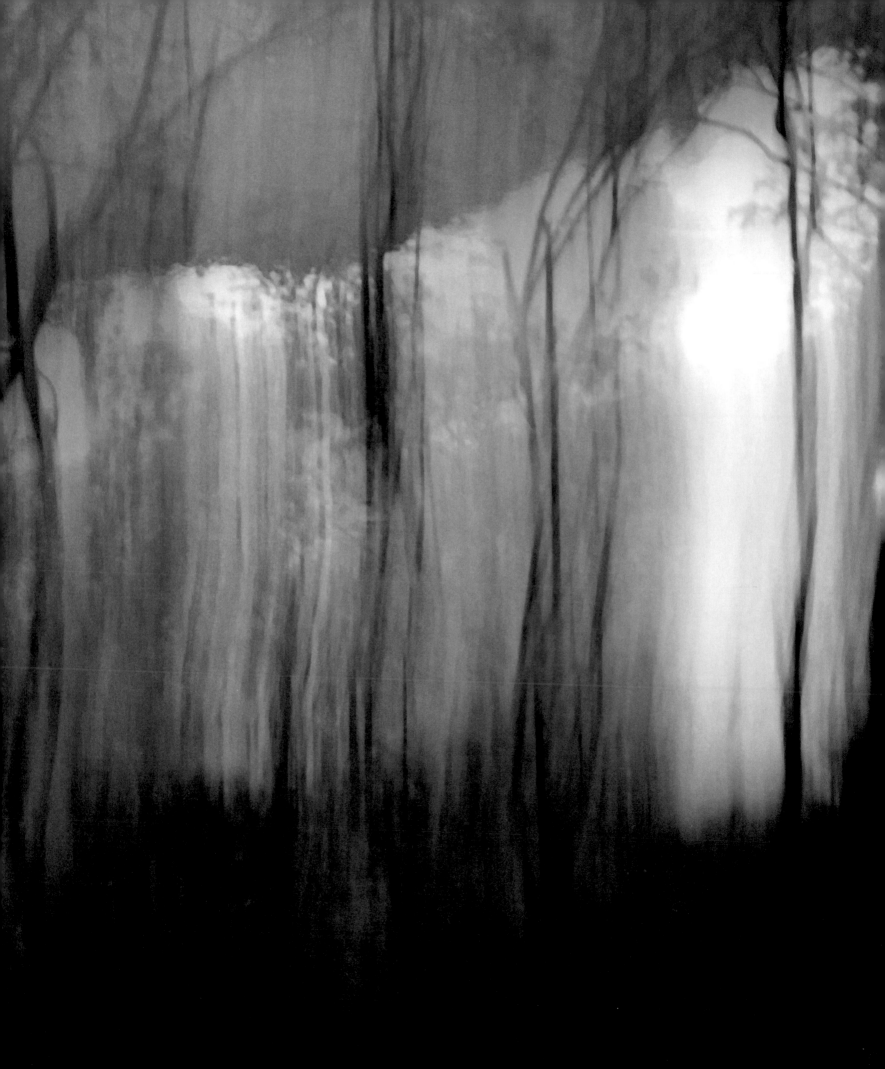

Reflected Lake 2, 2008
Pigment print on paper
149 x 120 cm

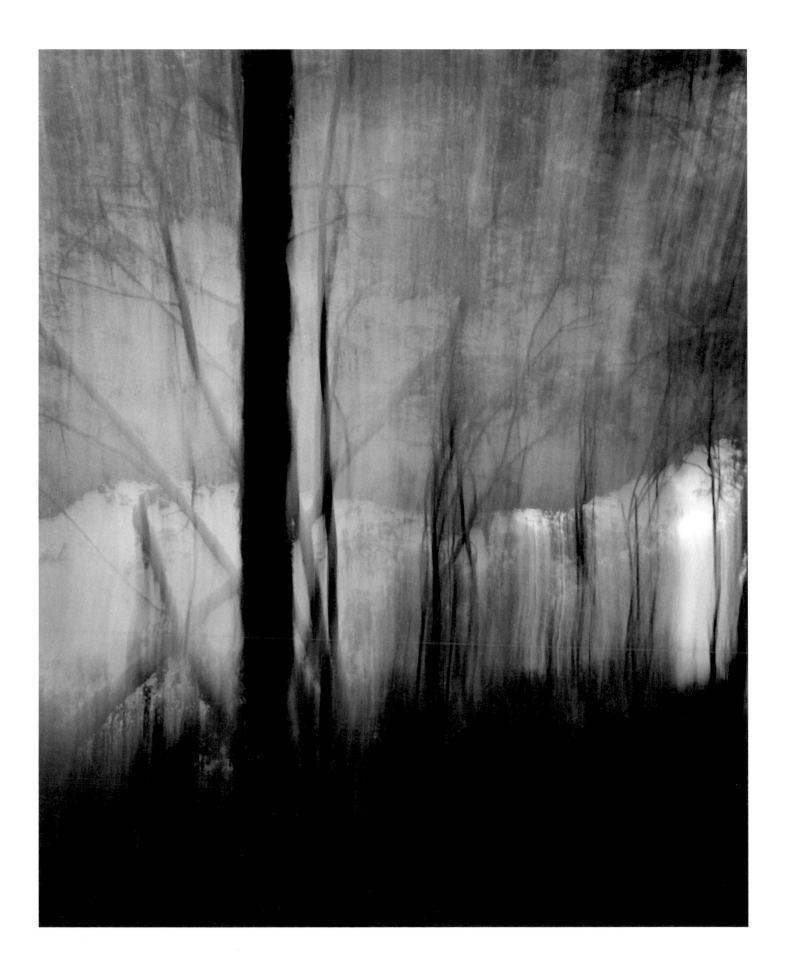

Reflected Lake 3, 2008
Pigment print on paper
149 x 120 cm

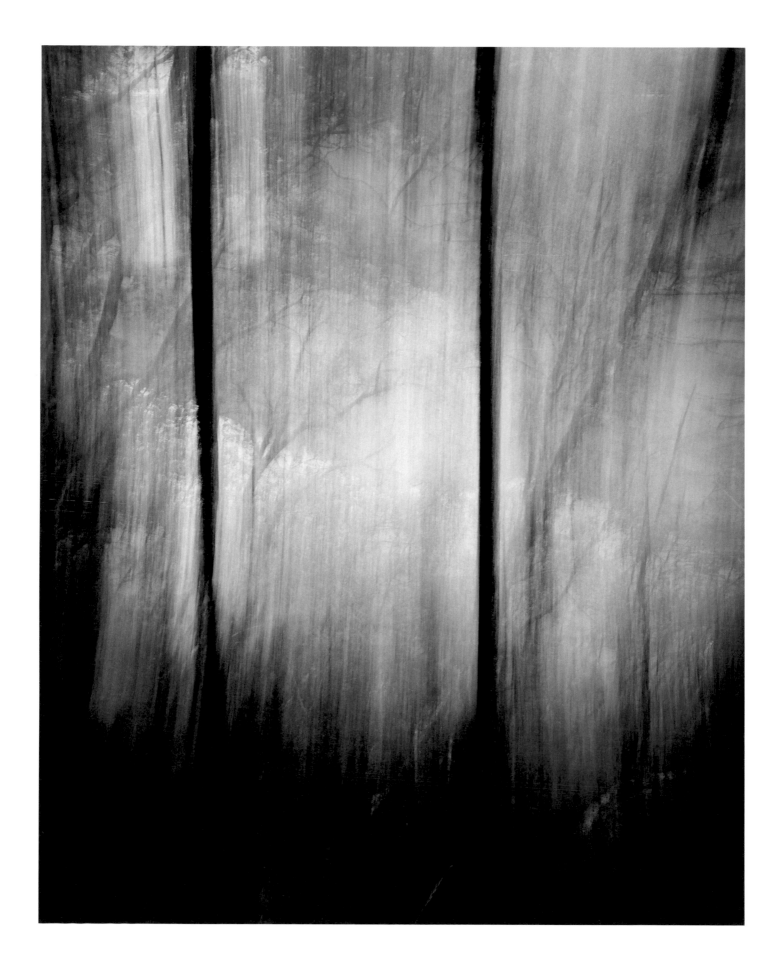

Reflected Lake 4, 2008
Pigment print on paper
76 x 65 cm

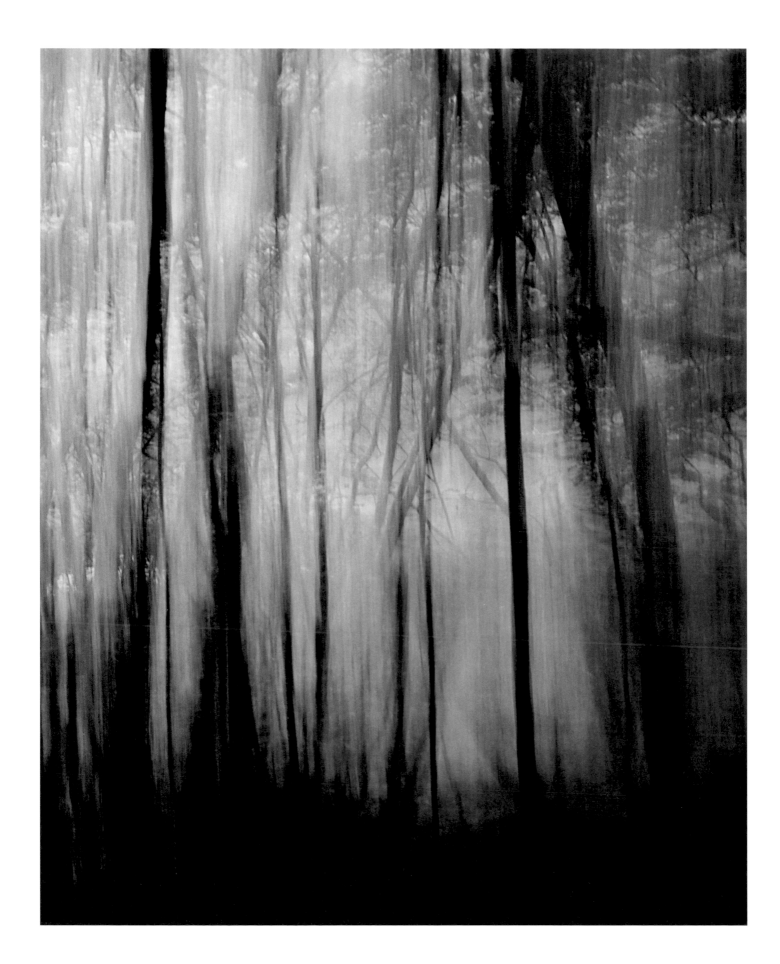

Reflected Lake 1, 2008
Pigment print on paper
120 x 149 cm

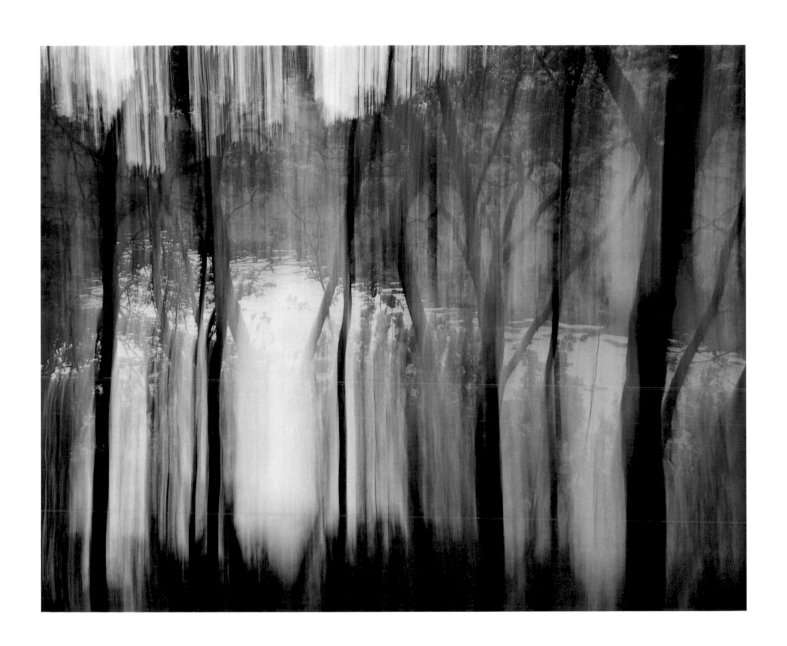

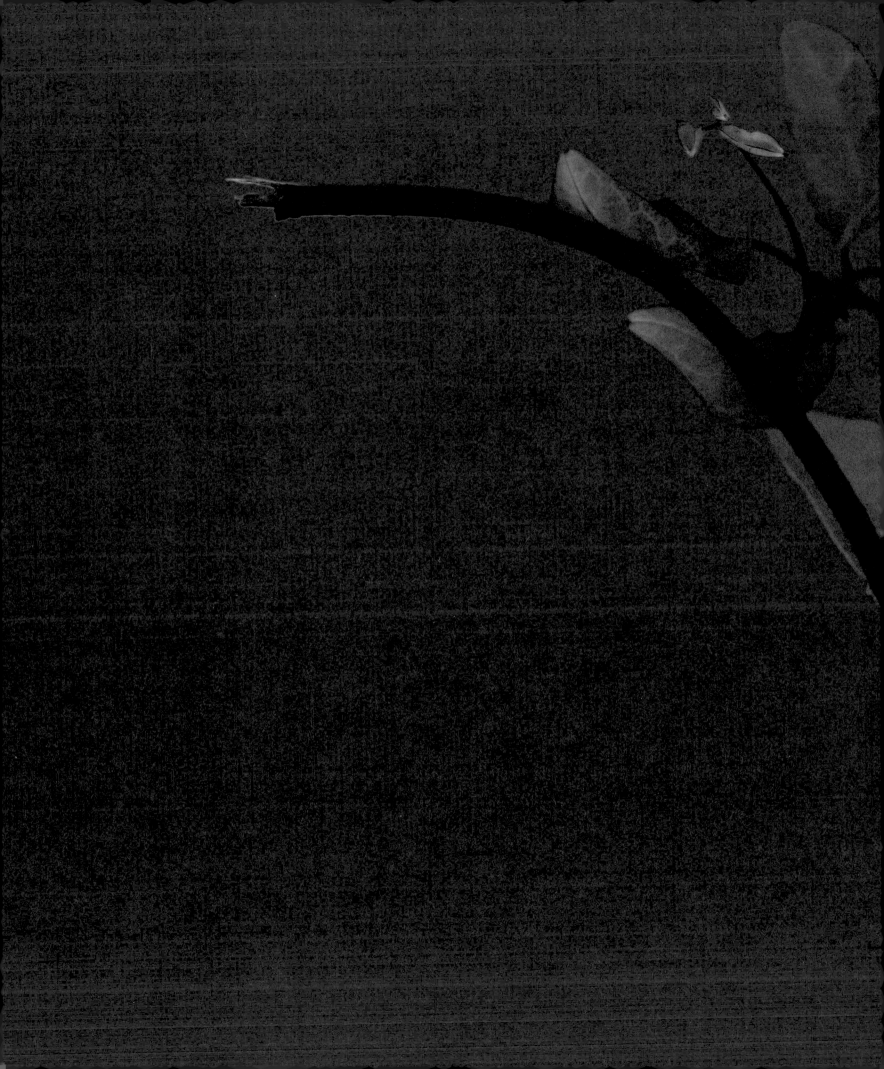

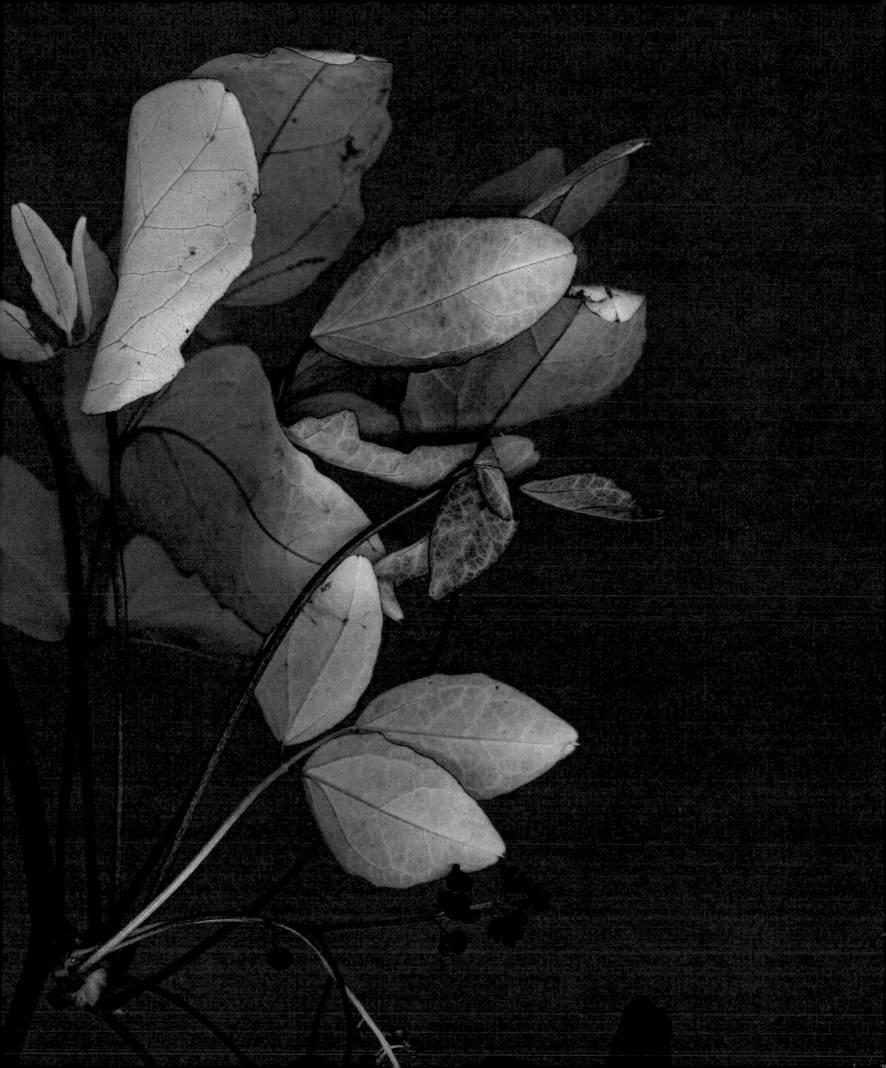

Exposure 2 (Akebi), 2008
Pigment print on paper
135 x 94 cm

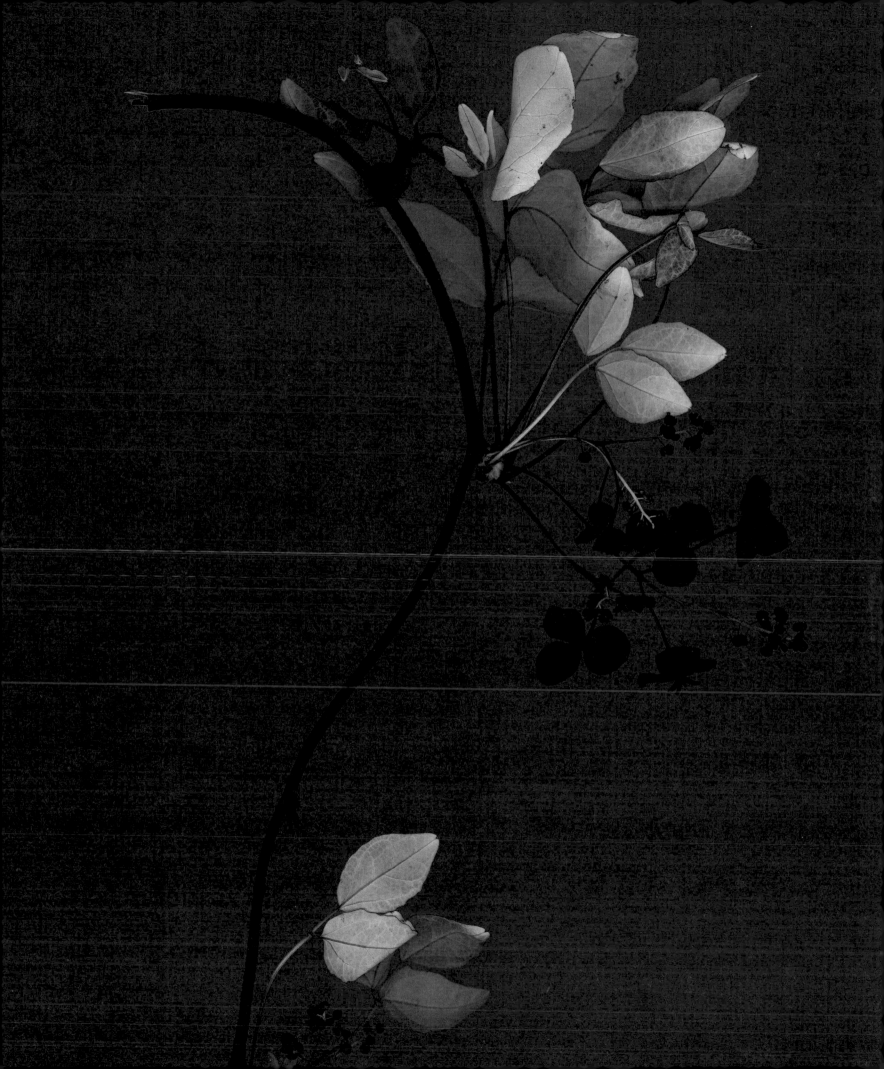

Exposure 3 (Uma no Ashigata), 2008
Pigment print on paper
135 x 94 cm

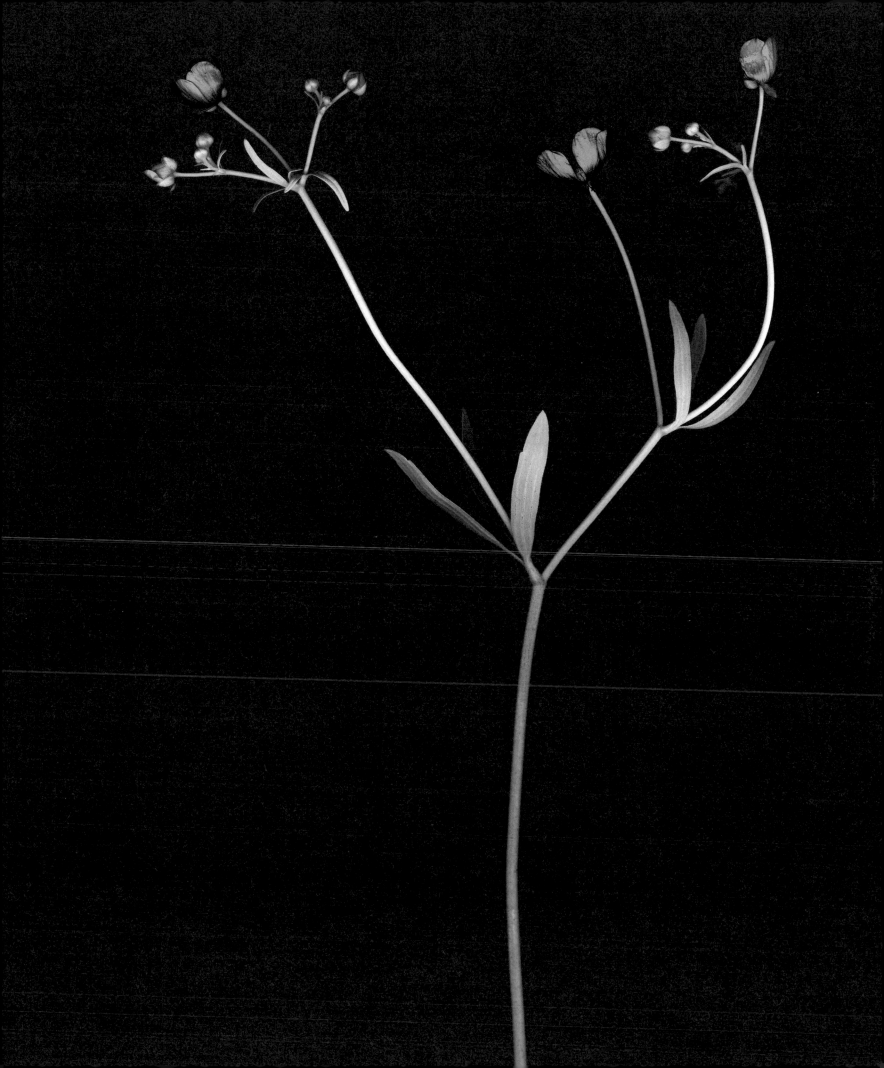

Exposure 6 (Christmas Rose), 2008
Pigment print on paper
135 x 94 cm

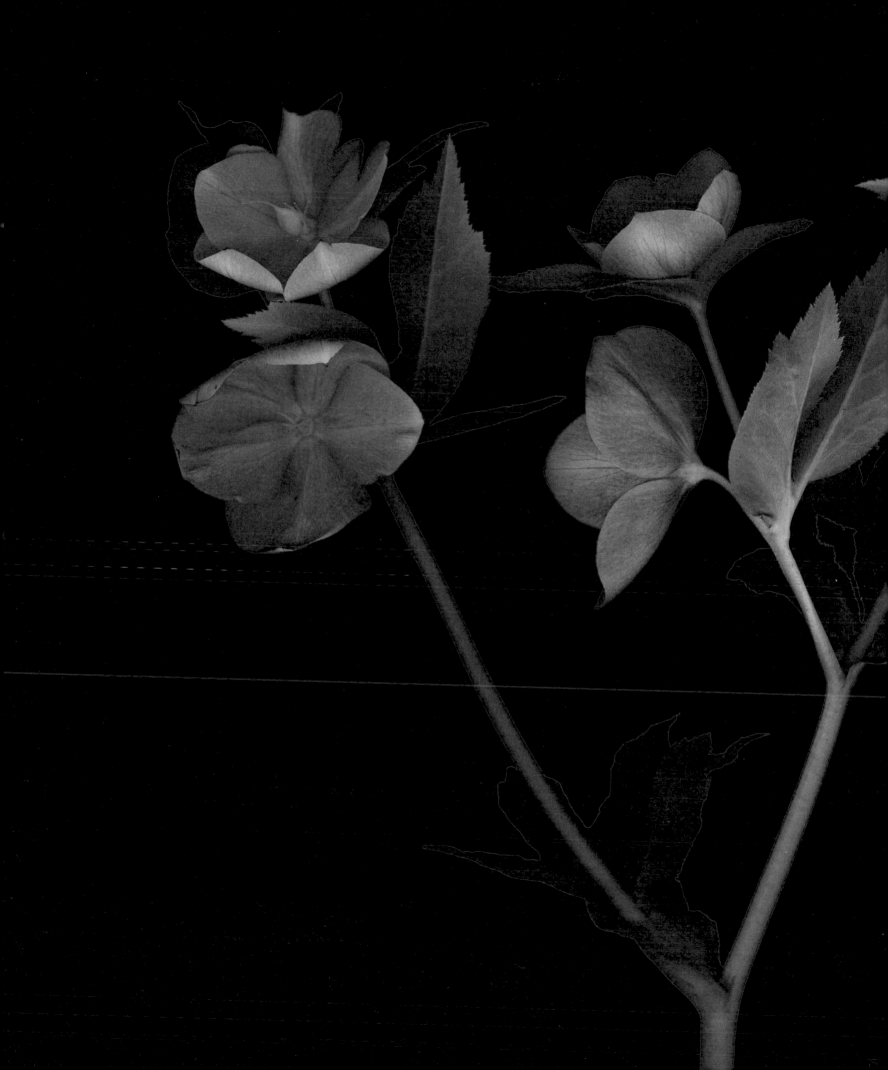

Extended Exposure, 2007
Pigment print on paper
50 x 50 cm

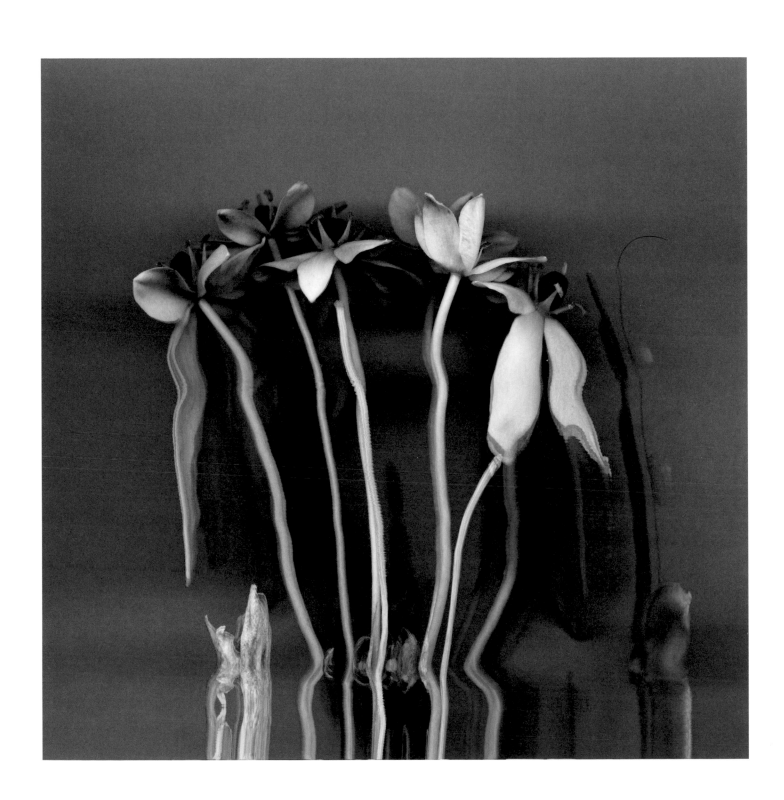

Exposure 1 (Azalea), 2008
Pigment print on paper
135 x 94 cm

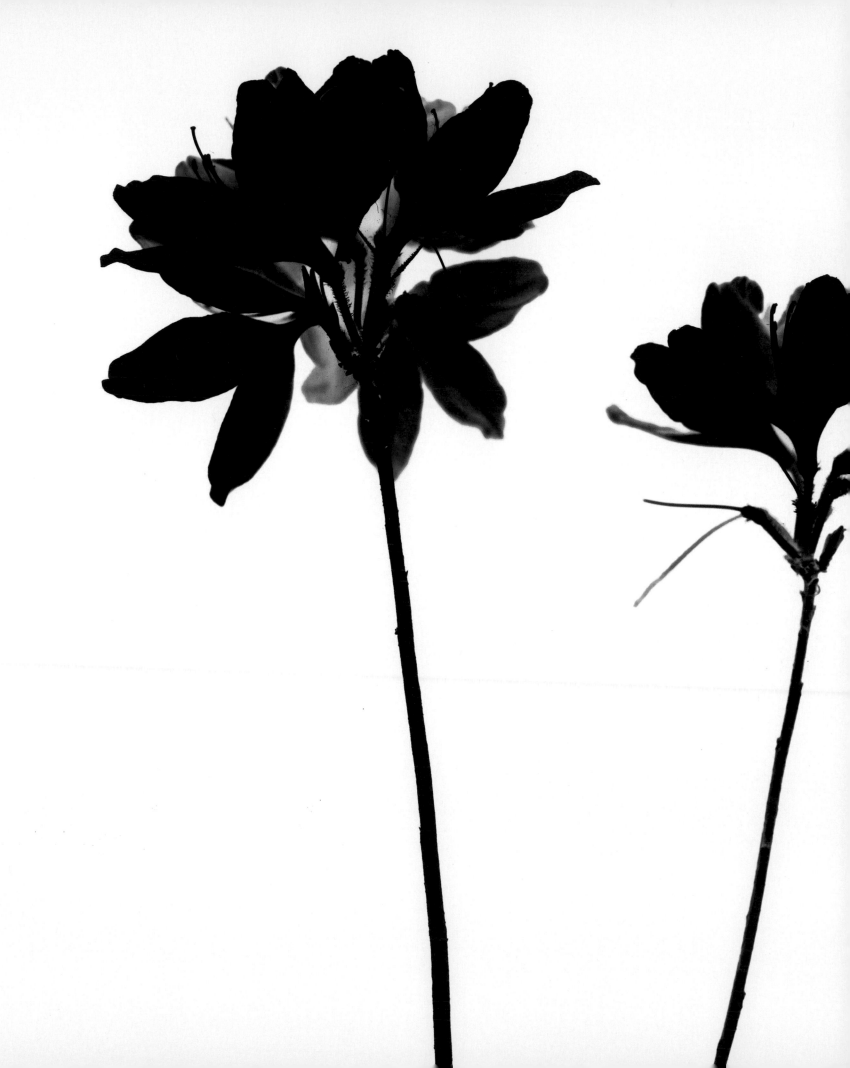

Exposure 4 (Dandelions 2), 2008
Pigment print on paper
135 x 94 cm

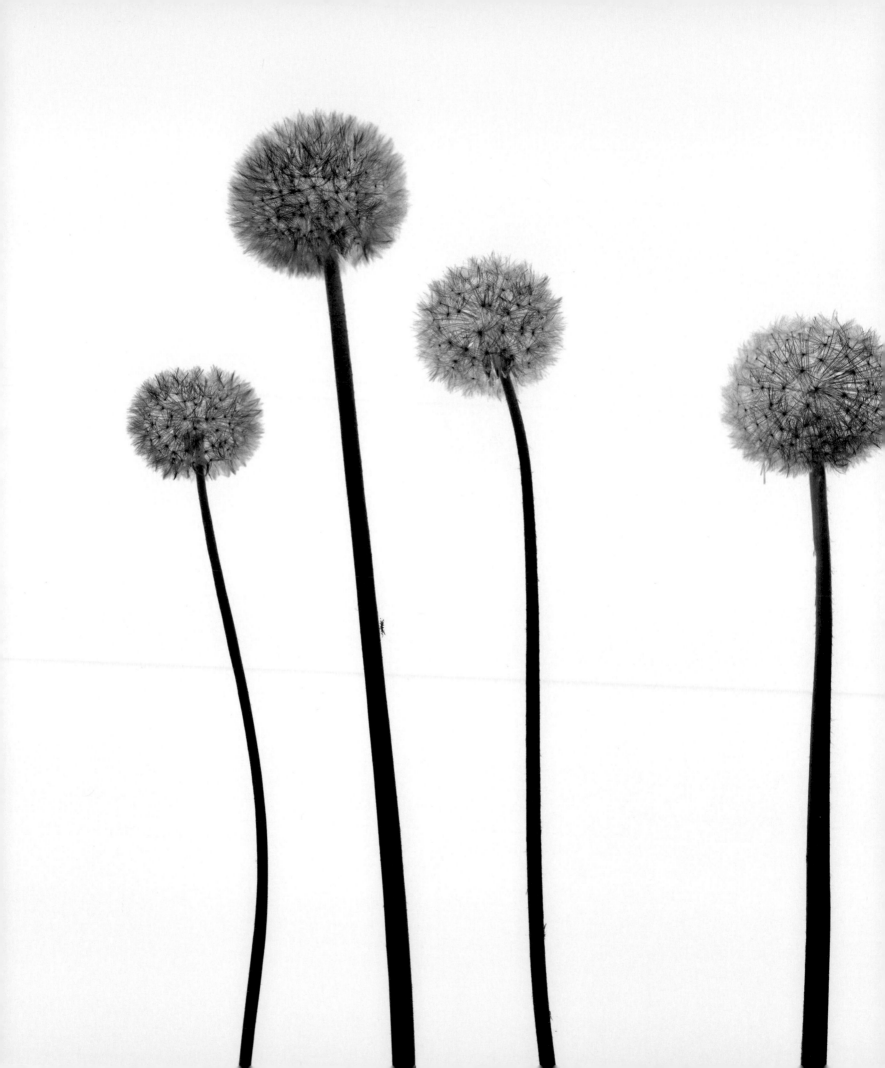

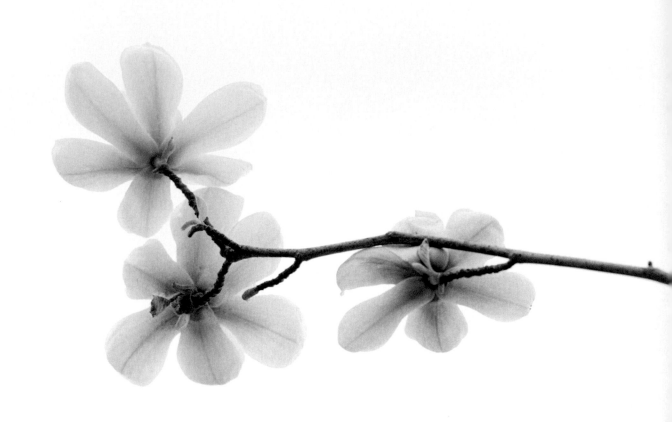

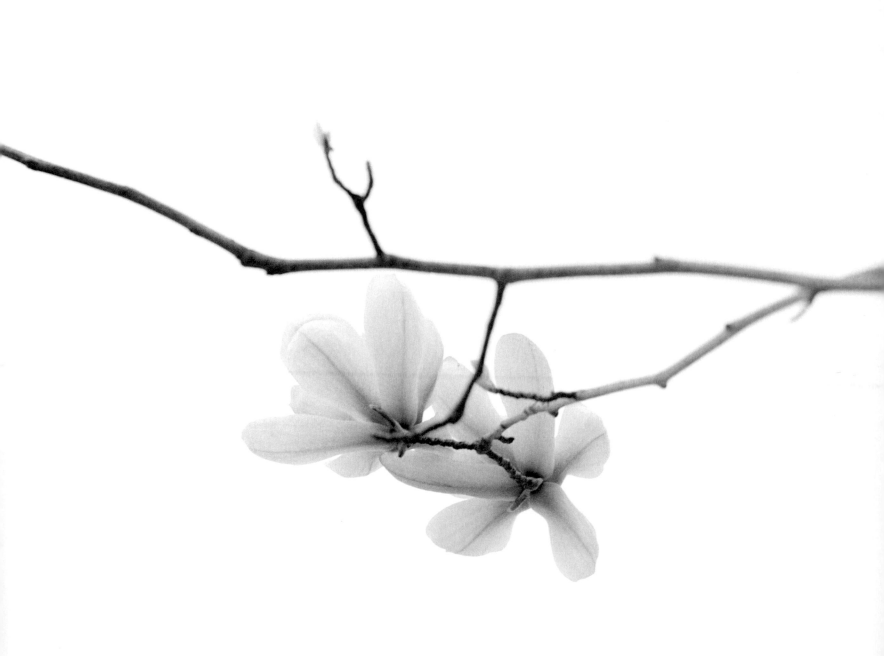

Magnolia, 2005
Pigment print on painted aluminum
116 x 132 cm

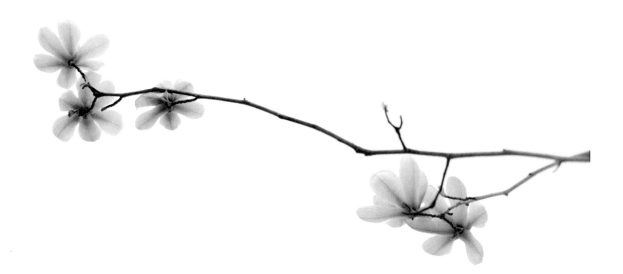

Tree with Flowers (Plum). 2005
Pigment print on painted aluminum
80 x 190 cm

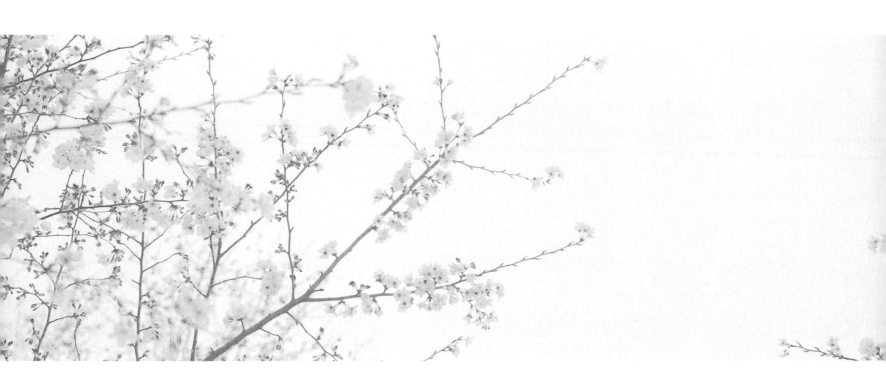

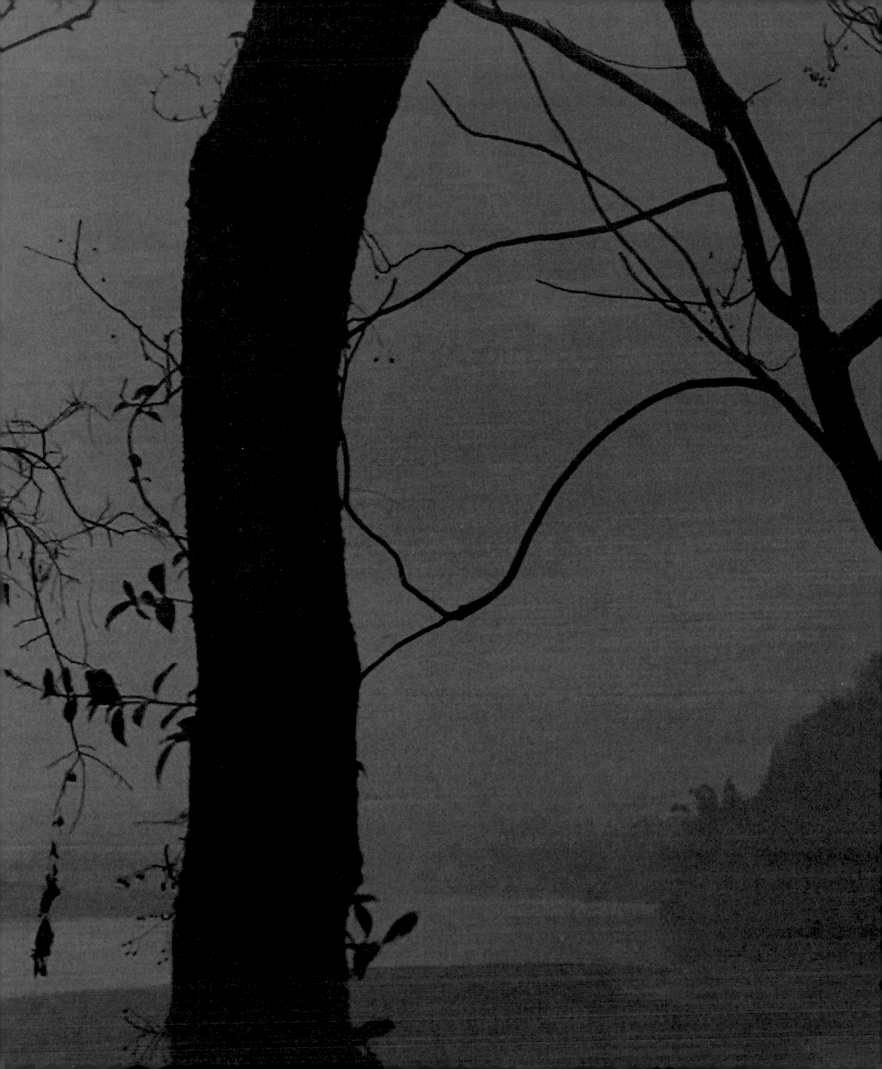

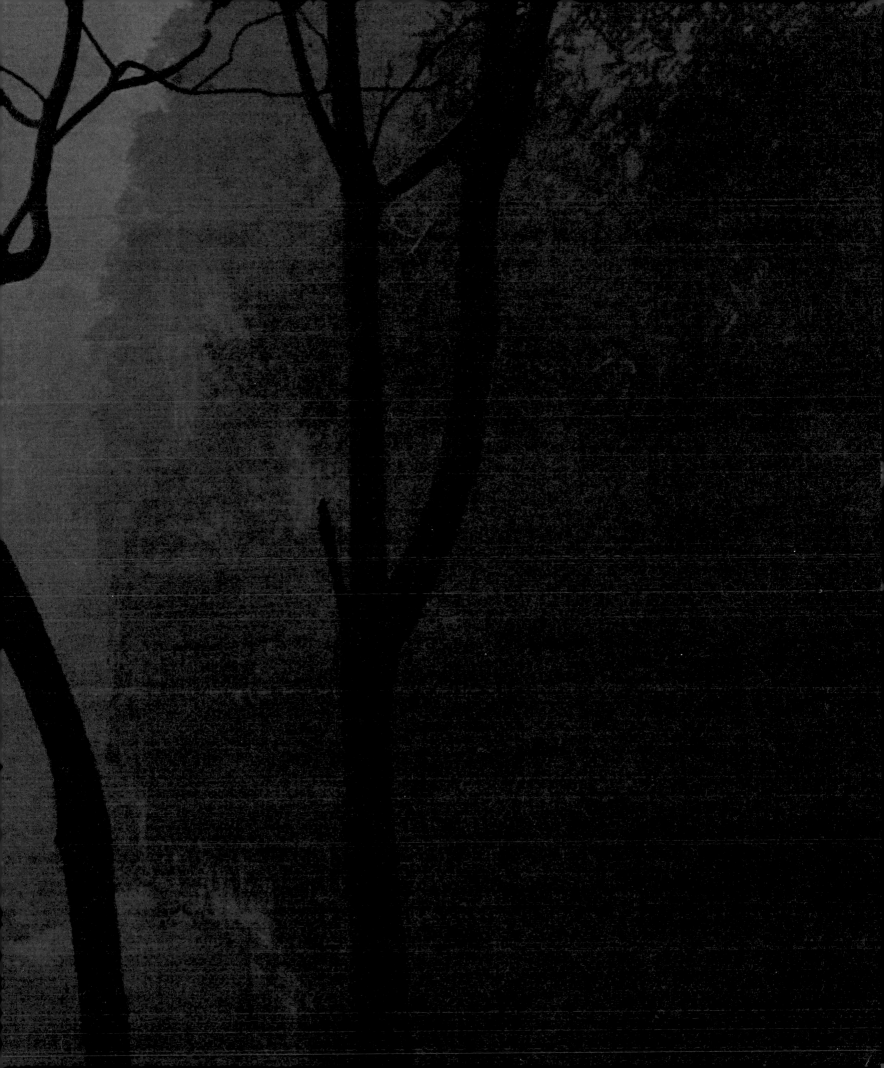

River, 2002
Pigment print on painted aluminum
97 x 97 cm

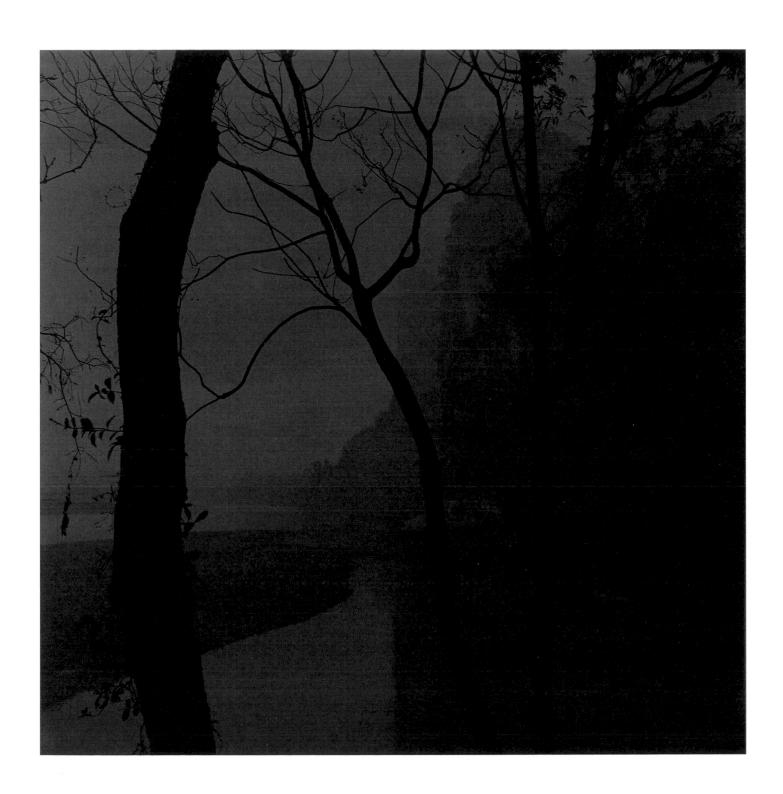

Untitled (Shanshui), 2002
Pigment print on painted aluminum
90 x 195 cm

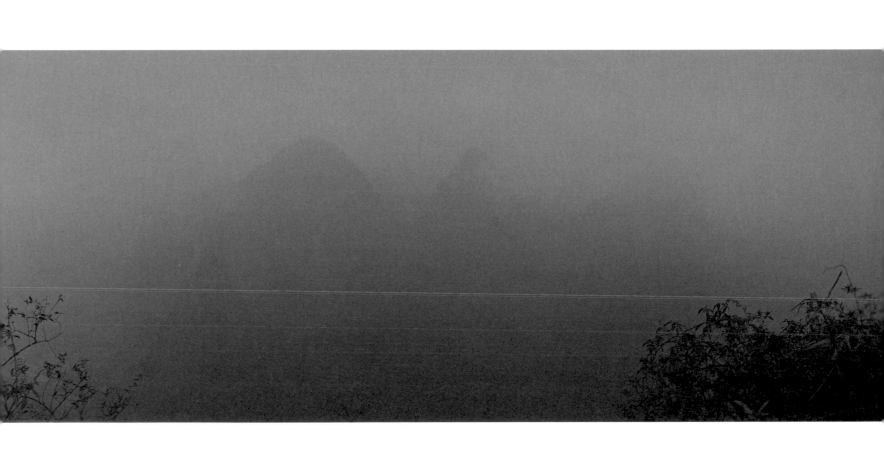

Field, 2002
Pigment print on painted aluminum
90 x 195 cm

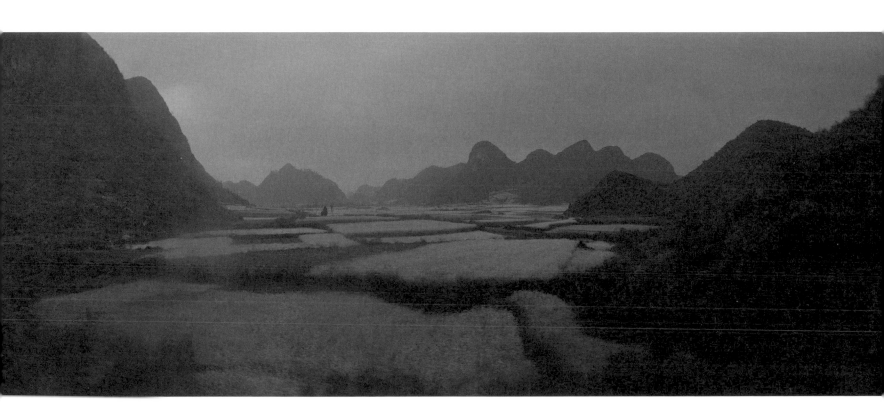

Desert II (Kumtag Shamo), 2004
Pigment print on aluminum
80 x 110 cm

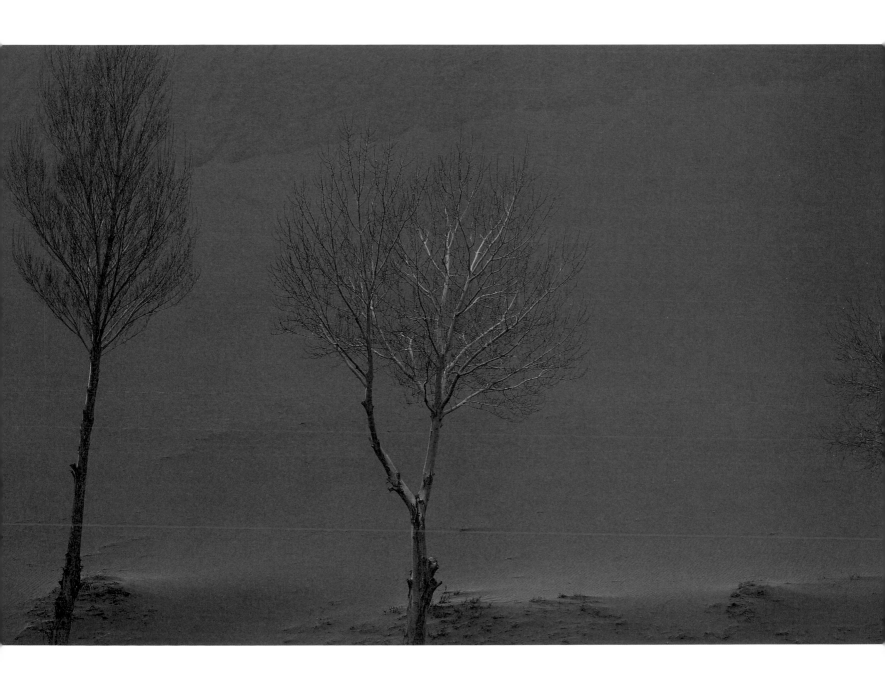

Desert III (Kumtag Shamo), 2004
Pigment print on aluminum
80 x 110 cm

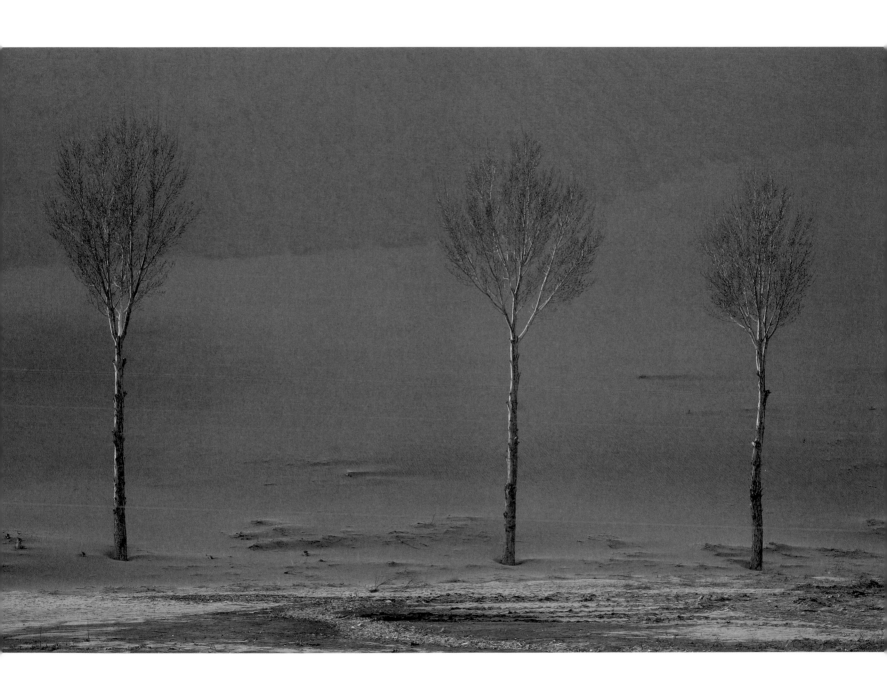

Mountain, 2001
Pigment print on painted aluminum
97 x 105 cm

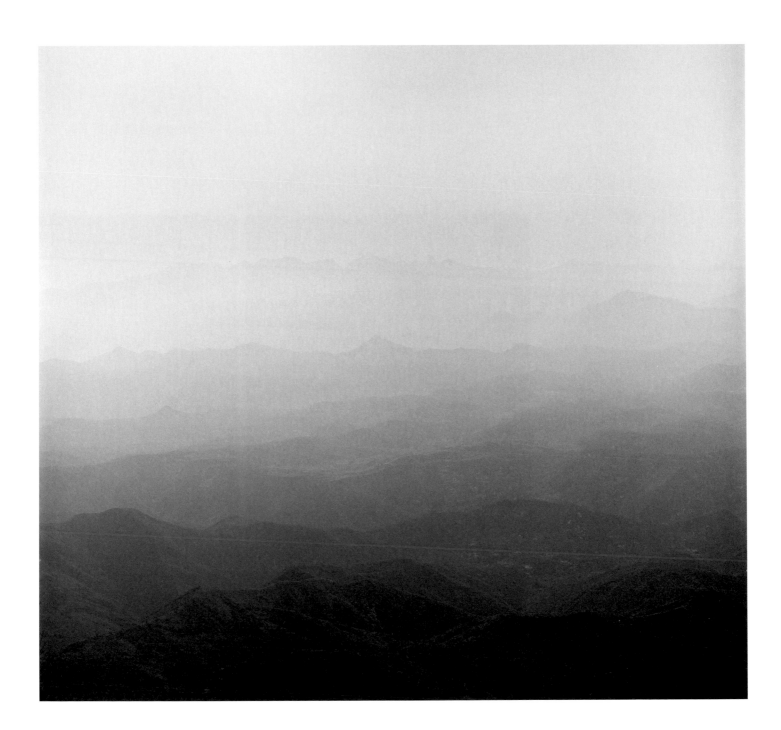

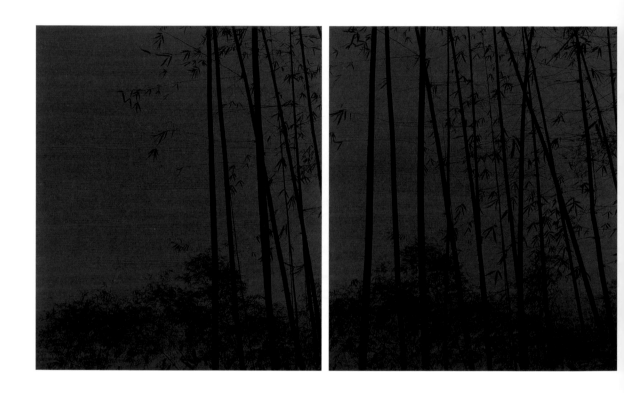

Bamboo 1–5, 2005
Pigment print on painted aluminum
112 x 500 cm

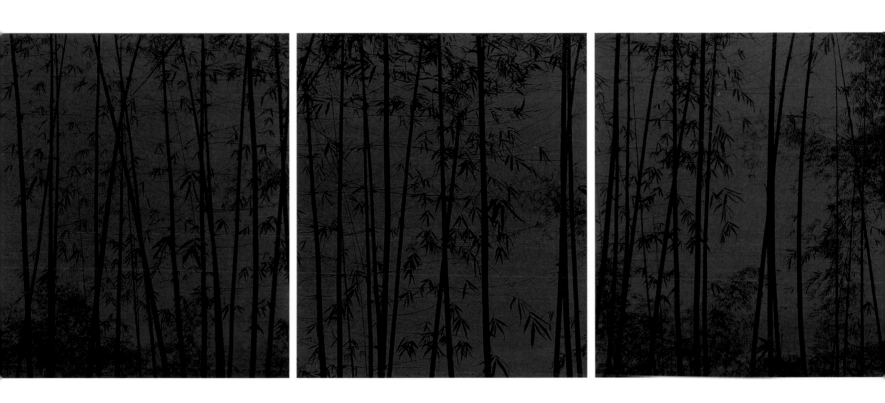

Black Trees, 2002
Pigment print on painted aluminum
97 x 97 cm

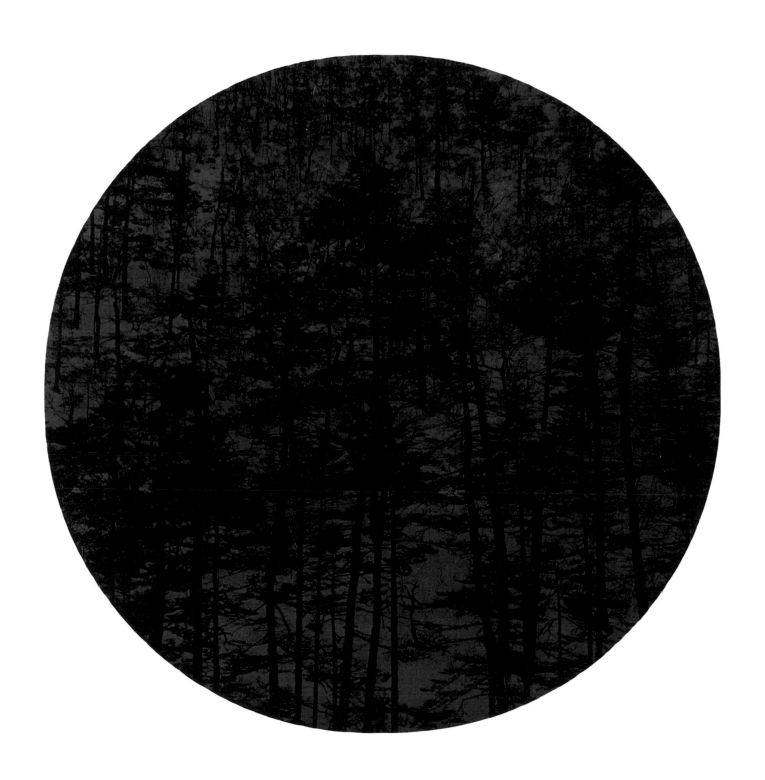

Bird 4, 2005
Pigment print on painted aluminum
21 x 21 cm

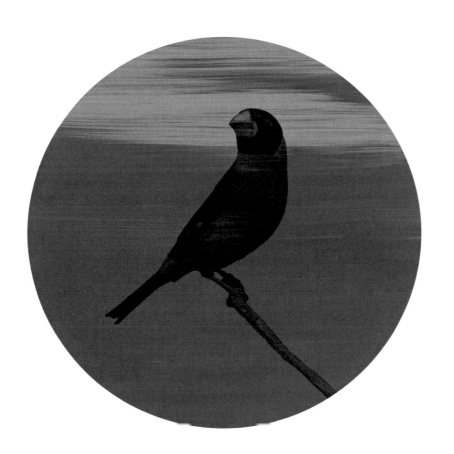

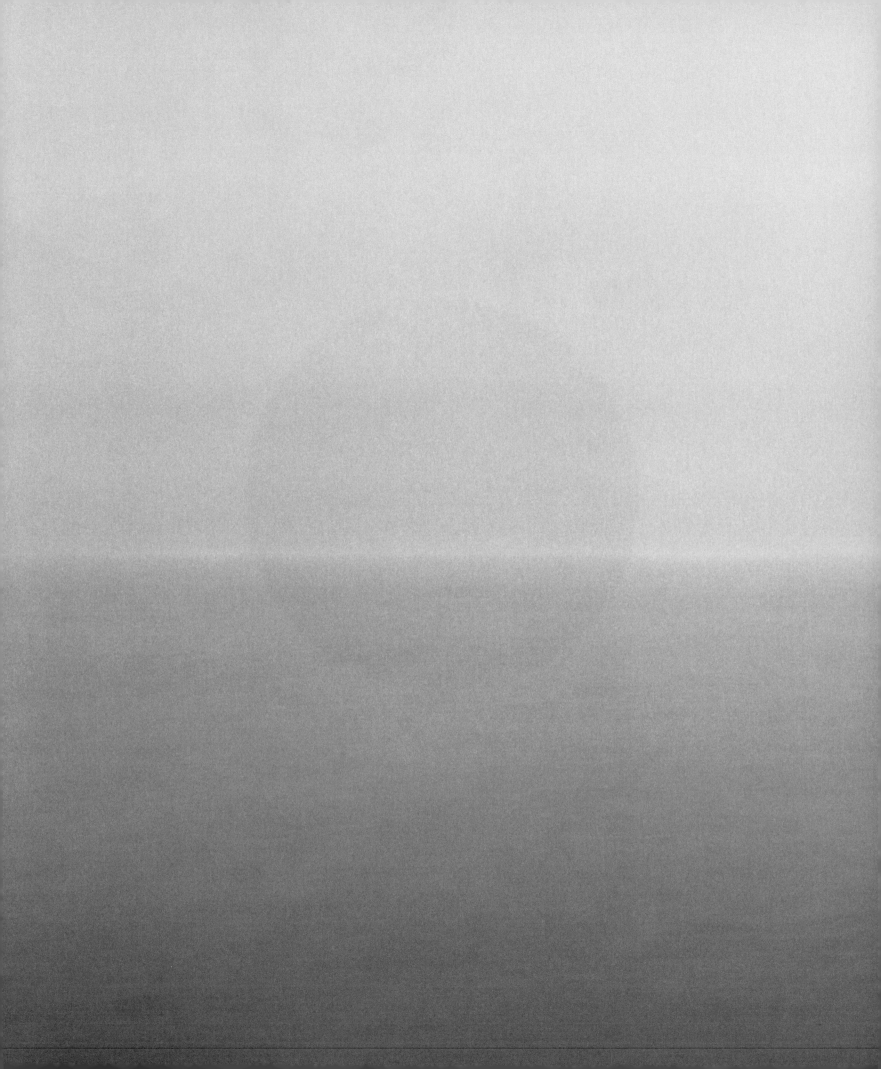

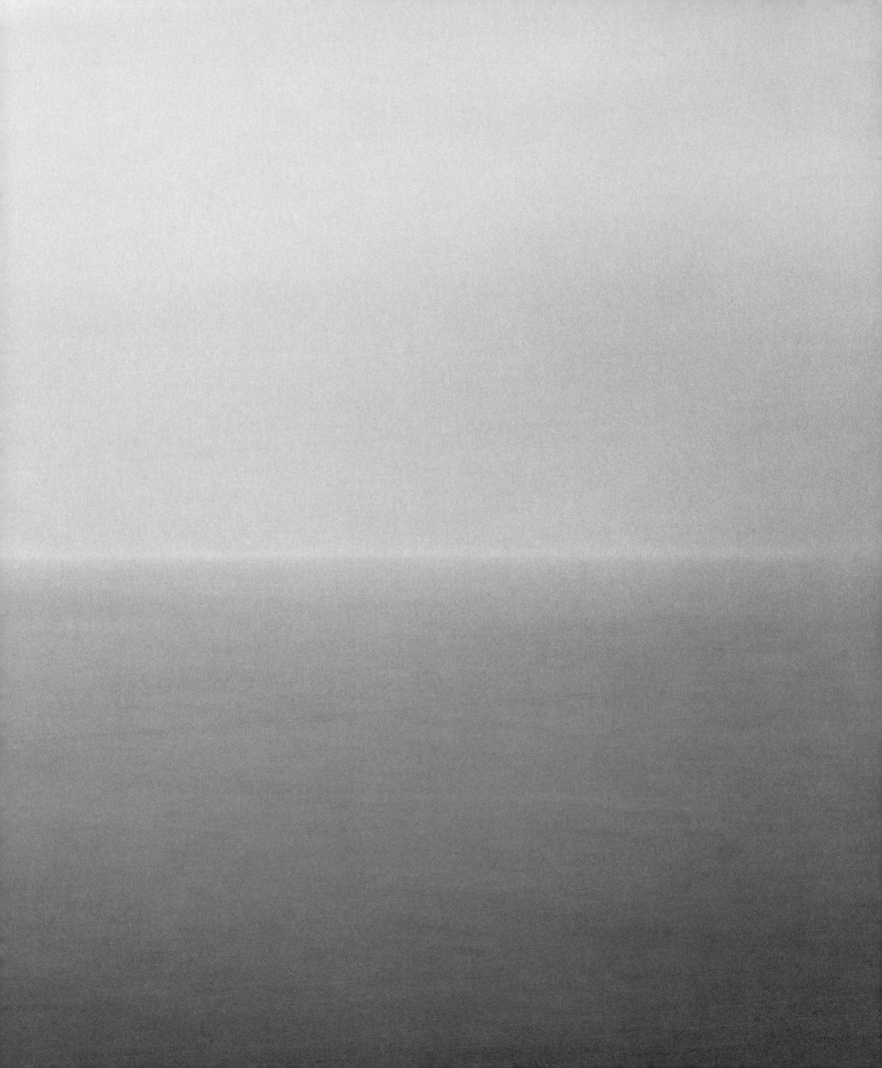

Horizon, 2005
Pigment print on paper
142 x 122 cm

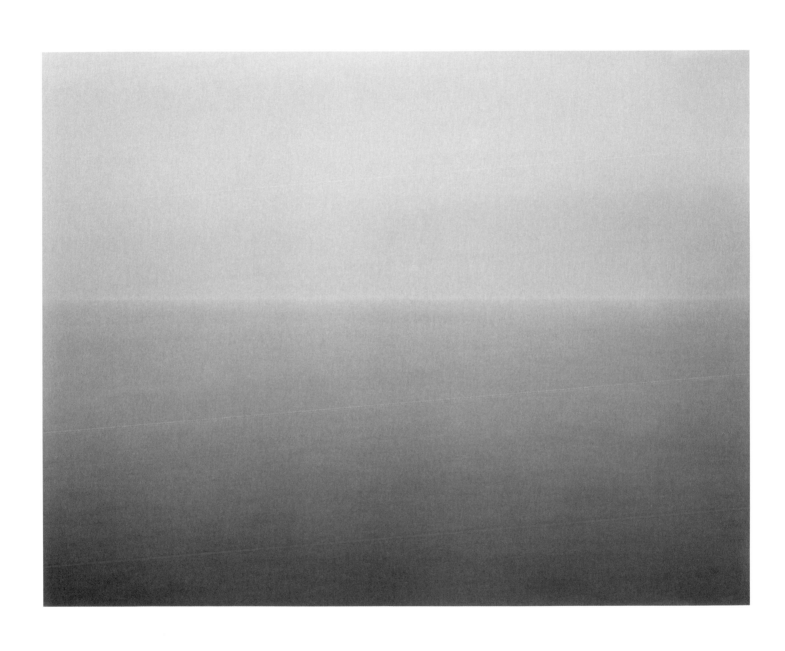

Rain, 2005
Pigment print on paper
65 x 80 cm

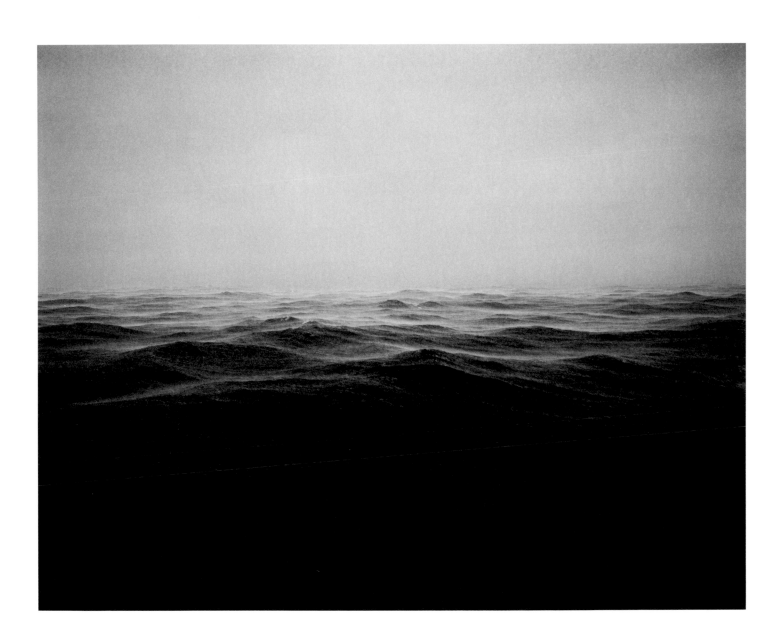

An Artist
of the Floating World

by ALISTAIR HICKS

UNTITLED (LAKE 6, FISHPOND)

At first sight it is difficult to believe that Sandra Kantanen's work is based in the present. She has taken the photographer's challenge to heart and literally stopped time—centuries ago in some idyllic Chinese "land" of mountains and water. The simplicity of her pictures encourages contemplation of trees, blossoms, mountains, and sheets of still water; but the modern eye, unused to contemplation, finds a friction under the misleadingly still surface. Though she appears to be at odds with today's tempo and theories, her work relies on modern solutions. She has mixed photography with paint. She paints with light. One senses the old values of a slower way of life and her interest in Tibetan Buddhism—there is a visual seduction pulling the viewer into a more thoughtful world—yet the hints at chaos through the occasional wash of color and the mix of techniques that would be heresy to traditionalists seem to accept that there are flaws not only in man-made thinking patterns, but in nature itself, and even in her "idealized" vision of it. The artist is a passionate and adept exponent of the spiritual. Though she has spent many years in China and studied the ancient Chinese art of landscape, she does not share the same unflinching belief in another heavenly world with the ancients. She knows she lives in a fast-changing world, she knows her "spiritual" and "real" worlds are not static. Her work does not offer us ultimate revelation, but rather a fluid interchange between colliding worlds.

There are echoes of her former professor Jorma Puranen's use of reflection in works such as *Untitled (Lake 6, Fishpond)* (2009), but the reflections have a very specific role. The fish may be swimming as countless fish depicted before have swum, but they look as if they are in the sky. They are fish out of water. Of course they are still swimming in the water, but they look as much at home in the reflected sky as in the water.

The fish are like the artist herself: she is remarkably at one with Chinese culture. "I'm not Chinese," she writes, "but I have been wondering where I got this overwhelming feeling of belonging in that culture. I somehow had to understand it. I felt this deep sorrow for something lost when looking at their landscape." She explains further: "I went to China originally as an exchange student in 2000 to do part of my master's in photography. I studied Chinese landscape painting and became completely obsessed

with the idea of trying to understand their way of looking at nature. As I found, most of the holy mountains they had been depicting for thousands of years were almost destroyed by pollution or otherwise turned into tourist spots. It became for me a search for a landscape that doesn't really exist, an idealized picture."[1] Her Chinese forerunners were, of course, equally interested in an idealized depiction, not mere reproduction.

Light becomes as much a spiritual as a physical tool for Kantanen. She learned about light in a series of Morandi-like still lifes she made back in 2000. "They were a rehearsal for me," she recalls. "I was trying to understand the nature of photography. I was interested in how the three-dimensional world transforms into two dimensions in a photograph. I figured light was all there was in this medium. I also felt I had to simplify the world I was working in. The real world was so messy, with too much information. I found landscape through China—the first time I went there. I started working with my still lifes in Beijing, I was sick in the beginning and couldn't leave my room. The other students thought it was weird to make pictures of dead objects with white, the dead color (the Chinese see white as the color of death)."[2]

Kantanen at times sounds as if she is tilting at windmills. She quotes Andrei Tarkovsky: "Art is born and takes hold wherever there is a timeless and insatiable longing for the spiritual, for the ideal: that longing which draws people to art. Modern art has taken a wrong turn in abandoning the search for the meaning of existence in order to affirm the value of the individual for his own sake. What purports to be art begins to looks like an eccentric occupation for suspect characters who maintain that any personalized action is of intrinsic value simply as a display of self-will. But in an artistic creation the personality does not assert itself, it serves another, higher, and communal idea. The artist is always the servant, and is perpetually trying to pay for the gift that has been given to him as if by a miracle. Modern man, however, does not want to make any sacrifice, even though true affirmation of the self can only be expressed in sacrifice. We are gradually forgetting about this, and at the same time, inevitably, losing all sense of human calling."[3]

The last words are crucial as these photographs are not just about water, air, and rock: they investigate the human relationship with our surroundings, I don't believe the artist is defeatist about her own age. The proof is in the positive lyricism of the work. The gently-layered compositions are affirmations of a belief in life. As Kazuo Ishiguro says in his novel *An Artist of the Floating World*, "It is hard to appreciate the beauty of a world when one doubts its very validity."[4] In borrowing his title for this short piece, I am not wanting to evoke the Edo high-life/low-life connotations of the phrase. Rather I am wishing to concentrate on the movement in Kantanen's work. There are no fixed boundaries between her "spiritual" and "real" worlds. Tarkovsky's vision of the dangers of unchecked individualism is no longer an unusual view. Others, such as Hou Hanru, have a more positive take on it: "Individualism is the fundamental notion of Western society: it is rooted in the worshipping of the romantic self. But somehow this generation now understands that this individuality is no longer individual, it's not a separate subjectivity."[5] With each successive photograph of Kantanen's one explores this new understanding of the individual, a new understanding of the worlds we inhabit.

NOTES page 125

Photography Integrated into Life, but Backwards

by TOMAS TRÄSKMAN

The art of Sandra Kantanen is based on what it refuses. The mind and the eye want to conceive a point in time or space that marks the beginning of all things (or at least of a limited set of things), but both mind and eye risk discovering, at that point, where all things will end. What Kantanen's art tries to refuse is exactly endings: "I signal a struggle, and it is a struggle. It is easier to perceive endings than beginnings. All you hear about is ends: of art, aesthetics, modernity, politics, nature . . . man. All it takes to see the end of things is to be au courant and blasé, but to spot beginnings one must be open and naive."

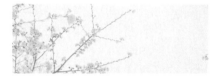

TREE WITH FLOWERS (PLUM)

In the case of Kantanen's photographs, fortunately, not too much effort is required to be open, or naive for that matter. Take, for example, *Tree with Flowers*. We are hypnotized by a bundle of meanings. Here photography that serves to put the flesh of fantasy on the Romantic poetics of "everything speaks," of truth engraved on the very body of things. A blossoming cherry tree . . . the light—too bright to be the sun—bewilders the eye. Her camera, like all cameras, incorporates ready-made the conventions of Renaissance perspective, and here she uses it for what it does best and for nothing else: making nature enter images. But she does not only do that —trees from a different continent and time come to mind. The picture of the cherry tree is not about making a naturalistic copy—almost any means are therefore permissible to avoid this, and the Chinese ink painters knew that better than anyone. This picture of a tree is also a part of this old convention in which paintings of a landscape, figure, plum, cymbidium, bamboo, or chrysanthemum were so sophisticated that an artist would paint only one motif during his lifetime. This painting is not interested so much in resemblance as it is in the result of intuitive glimpses or reflections on life and the things around us. Kantanen says a great deal with small means, although she is prepared to sometimes exaggerate a characteristic feature in order to increase the impression of reality. Rather than attempting to place her within a mythology of the innocent or infantile eye, Kantanen must be thought of as an observer who is astonishingly alert to whatever is anomalous in perceptual experience. But . . . Kantanen is not a Chinese ink painter, she is not Chinese, she is not even a painter. She springs from a different family tree. She is a European photographer.

At first sight, things seem clear: on the one hand there are conventions and practices; on the other hand, there is inspiration and a source. Conventions in art are, after all, not merely technical and aesthetic rules for the making and appreciation of art, they are above all social pacts. Kantanen's photographs are very contemporary. By this I do not mean to say that they refer to a simple, univocal reality—the reality of, say, us here today. No. Such a statement would be very far from contemporary indeed. Kantanen's photographs are a play of different "images" and conventions of representation. And because conventions are social pacts, her pictures are also a play between expectations and what happens to meet them. In her early photographs and the white-on-white still lifes, Kantanen seems occupied with shadows and blurring effects. The moment of exposure has a necessary vagueness to it. Or, to put it differently: the word is made flesh, but not in the blink of an eye. The photograph is integrated into life, but backwards. The first things we perceive are not the objects themselves but their shadows. And shadows can mean many things.

I pick three different but obvious examples: Plato, F.W. Murnau, and Peter Pan. For Plato everything perceived is a shadow. We are all prisoners, and all that we can see and hear are the shadows and echoes cast by objects we cannot see. For Murnau the shadow is an expression. In the film *Nosferatu* the shadow of the vampire climbing the stairs is there not only to arouse horror in the audience, but also as part of the style of expressionism and its placement of scenery, light, and shadow to enhance the mood of a film. Peter Pan (and the less famous Schlemiel) lost their shadows.

BEACH 1

In all of these stories the shadow functions as an index. In most reflections upon their essence shadows lack inherent significance, being but the ghostly doubles, the incorporeal traces of the opaque objects that cast them. But there are those who (like Peter Pan) wrestle with shadows as if they were more-or-less physical bodies. Like words, shadows display a peculiar doubleness: apparently mere traces of things, they are also a certain kind of thing in themselves.

Shadows are called forth in *In the Shadow of Young Girls in Flower*, the second volume of Marcel Proust's novel. The contours of the beloved girls are restored to a vagueness that facilitates the fictions of falling in love. And 'in 'The Opaque', Italo Calvino sounds out the link between the elusive nature of shadows and the nature of signs and the practice of writing. Calvino dwells at length on the relation between the shadow and the object that casts it: the 'tenuous and uncertain' shadow of a fig tree in the morning, he notes, 'becomes, as the sun climbs, a black drawing of the green tree leaf by leaf.'[1] A similar thing happens in Kantanen's pictures. When you take a look at *Beach 1* it is quite easy to construct an equivalence between the two practices: Kantanen's photographs and Calvino's fig tree. The photographic technique used in *Beach 1* produces a *contre-jour*, backlit effect, but the interesting thing is not so much the light as the black shadows that divide the picture into different vague forms. As you notice, I read this photograph unconventionally: I present the trees as shadows rather than trees. I claim that the picture addresses "the vague." This vagueness should not be confused with the erroneous or accidental. Such an interpretation would produce an unnecessary dialectic in which Kantanen's photographs would stand in opposition to exact geometry. The photographs would then correlate to inexactness and to the

accidental, which always is an approximation of exact geometry. *Beach 1* reexamines the composition of the visual world. Focusing on a tree yields a world already known through habit and familiarity. When one deliberately moves one's eye from one fixed position (the tree) to another (the shadow) the picture loses detail but, more importantly, becomes something other than what it had just been, and this results in a new relation to what now occupies the point of focus. This is the point where we leave Plato, since Kantanen's shadows do not play out in the ideal space of abstract geometry. Their vagueness is the result of the forces of matter, whereas the exact and the inexact are only assessments relative to a purely geometrical model. Perceptual constancy is the phantom in these "shadow pictures," and the world thus seen is no longer identical to itself. This brings me back to Calvino. "For Calvino writing is an act of 'reconstructing the map of a sunniness that is only an unverifiable postulate for the computations of the memory.' Writing is essentially sciagraphy—from *scia*, meaning shadow: sciagraphy is a form of shadow-drawing. Words generate a play of shadows whose contours trace out a transposed image of the world. . . . Writing then functions as a sort of opaque screen on which the world can record its own existence."[2] The world, then, is not an object that is observed and documented, but an active "recorder" of its own existence. Kantanen's photographs could be interpreted in much the same way. They are meetings between two worlds, two recorders: the photographer-being and the world. Hence the radical naiveté of the question raised by these works: can nature enter images? But not only that: can the images enter nature? Why not, when after all the world as well as the human being is an open port? Alienation and isolation are overcome when individuals understand their necessary integration into a self-regulating, interlocking feedback loop. What we witness is a beginning in the form of a clash between two forces of openness.

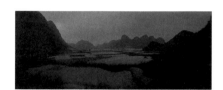

FIELD

The light in pictures like the above-mentioned *Tree with Flowers*, as well as in *Field*, reveals itself. The photographs have their light in-built, almost like a television image. In *Field* especially, everything in the landscape seems to be moving towards or away from the center. We are forced to look at the center, as there is nothing else to refer to. At first I thought it was a wind blowing over the fields that produced this phenomenon. But no—the phenomenon is produced by fluent, transparent, shimmering "shades" all over the picture plane. (That these shades are actually stains of fat from a grilled duck applied to a train window is only a side twist in the bigger operation of things. A picture is, after all, not produced or appreciated with a culinary recipe at hand.) Kantanen is, as I said earlier, prepared to exaggerate in order to increase the impression of reality. In *Field* the landscape reveals itself, its source is itself, the landscape becomes, in our eyes, its own cause. Did I use the word "reality"? Yes I did, didn't I? Funny, because her photographs seem so unworldly and detached (don't they?)—pure aesthetic pleasure, a sort of spiritual self-rescue. Kantanen is very concerned by questions of reality, reality as making presence present. Why? Well, firstly, because of self-preservation. What is reality today in a cultural climate of apocalyptic discourses, where there are only ends and everything is an image? Exactly where is the content? Where does the image begin and reality end? Examining Kantanen through the "loss of the world" reveals how her work coincides with much more than a domain of the optical and how the pictures

are a product of a broader engagement that is not only social but also corporeal. To what, then, is Kantanen attentive in the images *Tree with Flowers* and *Field* if not to the activity of the eye, to visual sensation, to wavelengths of light?

Kantanen is driven by curiosity: "How can the same procedures both create and retract meaning, both ensure and undo the link between perceptions, actions, and effects?" This curiosity and a certain anxiety which comes as its companion led Kantanen to an experiment with technique that has occupied her and characterized her art in recent years.

Look at *Extended Exposure*. It is photography as the skin peeled off things. I'll try to sort out the three alternating aesthetic experiences I have upon seeing it. I am tempted to describe the first one as mysterious, the second one as sensual, and the third one as conceptual. Reflection on these three experiences will, however, lead me to conclude that they all have something to do with the technique used in and the materiality of the photographs. Kantanen has developed a completely new technique. In a time where so many different techniques are on offer already, a decision to produce a new one should be regarded as an inquiry rather than an attempt to produce a certain result. So in Kantanen's case technique is a question rather than a solution to a problem. Kantanen prints her photographs with pigment on acrylic paintings made on metal plates and finishes the pieces with varnish. What she does is unite the material—pigment or other—and the two-dimensional surface. And she does it in such a way that you are in no doubt that she is using real paint. So is she actually painting? Or is she making photographs? Well, she is mixing, and this mixing of materialities is conceptual before it is real. Painting is, as my art history professor put it, "pigment on a surface." The art of painting is the specific realization of nothing but the possibilities contained in the very materiality of colored matter and its support. But this realization must, according to another professor, Jacques Rancière, take the form of a self-demonstration. I propose that it was this element of "self-demonstration" that drew Kantanen to painting. The same surface must perform a dual task: it must only be itself and it must be the demonstration of the fact that it is only itself. As I said earlier, Kantanen is not interested in copying. And, actually, photography did not become an art by employing a device opposing the imprint of bodies on their copy. It became one, and here I draw on Rancière again, "by exploiting a double poetics of the image, by making its images, simultaneously or separately, two things: the legible testimony of a history written on faces and objects and pure blocs of visibility, impervious to any narrativization, any intersection of meaning."[3] To continue my proposition, Kantanen mixes a form for self-demonstration (painting) with "pure blocs of visibility." In this way she marks a beginning: visibility begins *here*. Rather than saying "this is a forest," or "this is a bird," or even "this is the picture of a bird or a forest," the photographs try to avoid the artifice of any link, they express the power of the just-begun; or, put differently: of creation. In this way she works on the active interface of being between, as we stated above, "two forces of openness," between creating and what is created. She is creating art, and art is nothing other than the process whereby material is transmuted or spiritualized. Art is the process whereby actual incorporation becomes virtual incarnation. Art's medium is the actual or material, the stuff of embodiment: life has to

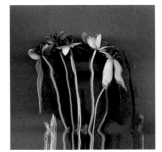

EXTENDED EXPOSURE

be made into an image. So she struggles with the age-old convention that proposes that art, before anything else, is an answer to the question, "How can a moment of the world be made to exist by itself?" i.e., independently of the situation and the material in which is actualized?

During a recent studio visit, Kantanen told me, "I have to return to China. My landscape is there." These words echo the stories of poets and impossible loves. The distant place (or princess) expresses itself as an eternally unfulfilled passion and a source of sweet unhappiness. She tries to counterbalance the banality of this statement (sometimes banal is just banal) with a smile. But it is quite evident that this "coarse daughter" of nature unashamedly abandons herself to a powerful impulse. There is a kind of irony here as well. The Chinese ink painters haunt Kantanen with their conventions, their imperative "to focus"—concentrate on only one motif during your lifetime, Sandra. Kantanen, of course, struggles. Incapable of surrendering to this vulgar commonplace, this "omnipotence of a spot" somewhere in distant China, Kantanen tries to measure herself against the laws of nature. This resistance can be observed in photographs like those of flowers in a scanner, in which she uses photography to discover a power rebellious enough to raise her above nature, above and beyond the reach of "her landscape" in China. The danger in such an endeavor, of course, is that you might succeed. One day you find that you have entered a world infinitely remote from all human beings.

It would be quite futile to deny the existence of an enigma in Kantanen's photographs. But to what does this enigma invite us, if it is not to the voluntary sharing of its operation? Kantanen's photographs try to teach us that the world does not present itself as a collection of objects. This does not imply that the world is "falling apart." The very idea of the picture as a malleable entropic force susceptible to fatigue, distortion, and dissociation would be unacceptable to Kantanen. *Still Life I* works with an imperative to de-objectify at the same time as it arranges an operation of capture. The result is a picture in which presence is more essential than objectivity. Through painting and its demonstration that the surface is only itself, Kantanen invites us to enter into the enigma. She demands that we delve into the way the picture operates. To enter into a picture—not in order to know what it means, but rather to think what happens in it—you need only to concentrate on what *takes place*. And what is taking place in photography is—and this is a banal observation—exposure and capture. It has, of course, been a long time since the chemical processes of photography, the mechanism by which the visible becomes invisible (when the plate is exposed) and the invisible becomes visible (when it is developed), involved some element of surprise or even interest to us. Daily bombardment with images has made us forget that the chemical, and now digital, reactions take place in some region far beyond anyone's control.

These various experiments with optical fixation and immobilization have only confirmed to Kantanen that, first, conventional photography is truly "a convention" and, in this sense, a calculated project for producing agreeable representations in its spectators in the interest of social cohesion. But, however interesting photography as a technique to control and manage the perception and attention of the spectator is, this path only led her to austere projects of formal rigor. Second, that pictures like those

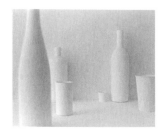

STILL LIFE I

of the flowers in a scanner certainly go beyond conventional photography and in this way constitute models of nonhuman perception. The scanner "recorder" interacts with the openness of the world . But how interesting is this aesthetic community of a lone scanner and a lone human? It just might be that Kantanen has drawn the contours of a "future aesthetic community." This relation is, however, even more of a "distant relation" than the one described above, Kantanen's "landscape in China." So she tries to create a new form of bond. The way she tackles the problem seems paradoxical: she travels to Russia.

In recent years Kantanen's work has involved *more* and *more* experiments and *fewer* and *fewer* images. A general impression of powerlessness and incoherence predominates some of these experiments. Kantanen looks on daily life with its kaleidoscope of accidents, catastrophes, and cataclysms and is dumbfounded. Aren't we—unless we are struck by apathy's nihilistic bliss—all? In an excursion to Russia, Kantanen tried to take a stand against the loss of meaning in which we are so often now not really actors but witnesses or victims. *The Belomor Canal*, a piece of geo-engineering dictated by Stalin and constructed by the forced labor of Gulag inmates (of which an estimated 8,700 died), seems to offer the perfect Museum of Horrors for this. Kantanen comes back from this scene overexposed to horror but with only one picture. One picture. The picture shows the canal, a mass-produced accident, and a bird, the witness of the . . . well, what? The canal, yes, but not necessarily the accident, since the mass-produced disaster exists *outside* our consciousness. The fact that Kantanen came back with only one image provides a counterpoint to the excess of images with which the news media daily swamp us. In this way it is less a picture of what can be witnessed and more a representation of the madness of voluntary blindness to the fatal consequences of our actions and inventions.

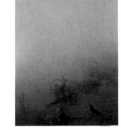

In sharp contrast to this experiment stands a series of pictures that were taken in China, in the regions of Emei Shan and Jiuzhaigou. Here the question of whether a representation of nature could in some way be life-enhancing traverses her work once again. These are the places that she has "to return to." In these pictures we encounter once again what I tried to signal earlier in this text between two ideas of the image: the common notion of the image as the duplicate of a thing and the image conceived as an artistic operation. Once again we encounter photography that serves to put the flesh of fantasy on the Romantic poetics of "everything speaks." It would be pointless to read *Untitled (Lake 2, Fishpond)* with any specificity beyond the general voluptuousness within the colors, the sublime confinement of the tree at the left, the nestled, intimate contact of the water in the lower right corner; pointless to speculate on the identity of wished-for physical and psychological states. But in these pictures truth is not only engraved on the very body of things—the artist herself has engraved the truth on these very bodies. "Clearings" in the midst of the light and foliage constitute "bands" or "animations" of radical fluidity in all attempts to seize or hold onto presences. (That these "clearings" are actually made digitally is only a side twist in the bigger operation of things. A picture is, after all, not appreciated with a Photoshop tutorial at hand.) The banality of the scene, or Kantanen's "conservatism," her avowed commitment to "the study of nature," reveal not only objects and their relations but nature experienced as

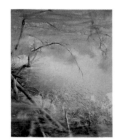

UNTITLED (LAKE 2, FISHPOND)

vibrations, animations, and chromatic echoes. There is a "want" in the meeting between two worlds, two recorders, the photographer-being and the world. A desire to present what is invisible to the naked eye: the quick of life. The reference to the photographer as a recorder brings to mind another "recording machine": Paul Cézanne. Cézanne shares with Kantanen an obsession with "the study of nature" and an occupation with a particular landscape (in his case, a mountain). Kantanen's occupation with plates and her experiments with scanners and printers, her openness to how a moment opens onto time recall Cézanne's metaphoric description of himself as a "sensitized plate," his aspiration to be a "recording machine" and "a damned good machine." The art historian Jonathan Crary, discussing Cézanne, describes this imaginary refiguration of Cézanne a "machine" as "an affirmation of his quest for a release from the grounded conditions of human perception. . . . Cézanne evoked a primordial image of the molten birth of the world, he would have done so only as the most available expression of an irreducible formlessness, of a world in process without horizons, without positions, a world only of vaporous, slowly vibrating color."[4] Now, in much the same way, Kantanen's art tries to keep alive the singular thought which has the naiveté and the strength to believe in photography as a record of the potentials from which life emerges. A coming together in composition. But Kantanen struggles with a different kind of separation between truth and its appearance than Cézanne. Today, when everything is image, the "loss of the world" organizes itself as a collective world—a community alien to its own essence.

Hitherto, a lot has been said about pictures and images, but nothing of exhibitions. In the exhibition the artist constructs a stage where the image manifests itself to a community of narrators and translators. The aesthetic place of the exhibition is a place for solitude and engagement, passivity and activity. The public's reactions to and comments on Kantanen's exhibitions of pictures from Emei Shan and Jiuzhaigou evoke a different kind of community than the one described above. One word that kept recurring when the spectators acted as active interpreters of the images was the word "joy." Here the spectators experienced joy. They translated the pictures, appropriated the images, and made them into their own story. And the community was one of "joy." But what is a picture that gives us joy? What is a joyful picture? True joy, writes the author Hélène Cixous, "drives us crazy." Because it goes beyond us, it is bigger than we are. In joy, Cixous observes, we "suffer from our smallness and we make superhuman efforts to be superhuman."[5] Joy is immediate, obvious, and banal. The pictures from Kantanen's landscape in China, *Untitled (Mountain 2)*, *Untitled (Lake 2)*, *Untitled (Lake 3)*, and *Untitled (Lake 4, Fishpond)*, demonstrate the latent presence of the superhuman in the banal. Photography integrated into life, but backwards.

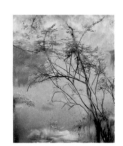

UNTITLED (LAKE 3)

NOTES AND REFERENCES

NOTES: HICKS

1 Sandra Kantanen, email to the author, February 23, 2011.

2 Ibid.

3 Andrei Tarkovsky, *Time Within Time: The Diaries 1970-1986*, trans. Kitty Hunter-Blair (Calcutta, 1990), p. 38.

4 Kazuo Ishiguro, *An Artist of the Floating World* (London, 1986), p. 150.

5 Hou Hanru, quoted in "Utopia and Contradictions of the Real World," *Art Works* (Ostfildern, 2011), p. 204.

NOTES: TRASKMAN

1 Paul A. Harris, "Life from the Other Side: Time in the Shadow of the Sign," http://myweb.lmu.edu/pharris/perec.htm (accessed March 17, 2011).

2 Ibid.

3 Jacques Rancière, *The Future of the Image* (London, 2007), p. 11.

4 Jonathan Crary, *Suspensions of Perception: Attention, Spectacle, and Modern Culture* (Cambridge, 1999), p. 342.

5 Mireille Calle-Gruber and Helene Cixous, *Rootprints: Memory and Life Writing* (London, 1997), p. 19.

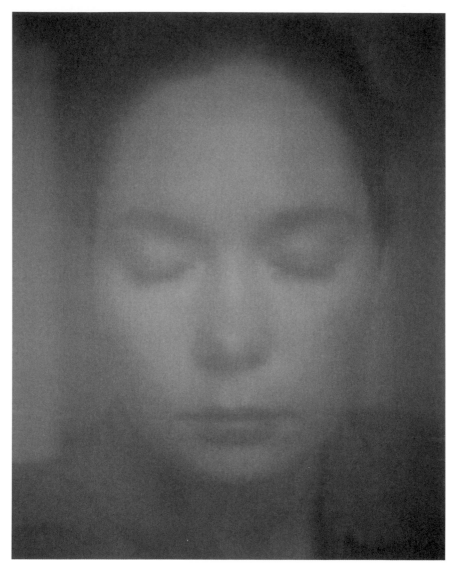

Self-Portrait, 2007

BIOGRAPHY

SANDRA KANTANEN
born in 1974, is a photographic artist from Helsinki, Finland

She earned a Masters degree in photography at the University of Art and Design in Helsinki in 2003. Part of her MA studies were completed in China at the Central Academy of Fine Arts in Beijing. She has shown her work in several exhibitions in Finland and abroad, including the Pobeda Gallery, Moscow, Russia, 2010; Bryce Wolkowitz Gallery at The Armory Show, New York, USA, 2010; Shiseido Gallery, Tokyo, Japan 2009; Aomori Contemporary Art Centre, Japan, 2008; Purdy Hicks Gallery, London, England, 2007; Hyvinkää Art Museum, Finland, 2007; Stenersen Museum, Oslo, Norway, 2006; Galerie Anhava, Helsinki, Finland, 2005; Galleri Brandstrup, Oslo, Norway, 2005; Museum of Photography, Odense, Denmark, 2004; Mikkeli Art Museum, Finland, 2003; Millesgården, Stockholm, Sweden, 2001.

She has participated in numerous art fairs (Paris Photo, Arco, Berlin Art Fair, The Armory Show) and she is a member of the Helsinki School.

Sandra Kantanen has works in several collections in Finland and abroad including The Museum of Contemporary Art Kiasma, The State Art Collection of Finland, The Helsinki City Art Museum, The Tampere Art Museum, The Rovaniemi Art Museum, The Pro Artibus Foundation, The olorVISUAL Collection in Spain, and Seydler AG Bank in Germany.

This book is published in conjunction
with the following exhibitions:

Pyhäniemi 2011
Pyhäniemi Manor Hollola, Finland
July 2 – August 14, 2011

Purdy Hicks Gallery London, England
June 23 – July 23, 2011

Christophe Guye Galerie Zurich, Switzerland
Helsinki School
July 7 – August 20, 2011

Copyediting: Vajra Spook

Graphic design and typesetting: Inger Kulvik-Kantanen

Typeface: Gotham HTF and Kozuka Gothic Pro

Production: Stefanie Langner, Hatje Cantz

Reproductions: Petri Kuokka, Aarnipaja

Printing: Offsetdruckerei Karl Grammlich GmbH, Pliezhausen

Paper: GardaPat Kiara, 150 g/m^2

Binding: Bramscher Buchbinder Betriebe GmbH & Co. KG, Bramsche

Published by
Hatje Cantz Verlag
Zeppelinstrasse 32
73760 Ostfildern
Germany
Tel. +49 711 4405-200
Fax +49 711 4405-220
www.hatjecantz.com

You can find information on this exhibition
and many others at www.kq-daily.de

Hatje Cantz books are available internationally at selected
bookstores. For more information about our distribution partners,
please visit our website at www.hatjecantz.com

ISBN 978-3-7757-3191-1

Printed in Germany

This book has received support from:
The Arts Council of Finland
The Swedish Cultural Foundation in Finland

Special thanks to:
Timothy Persons, Alistair Hicks, Tomas Träskman, Inger Kulvik-Kantanen
and everyone at Hatje Cantz and Aarnipaja
for making this book possible.